THE KATHARINE ORDWAY COLLECTION

YALE UNIVERSITY ART GALLERY

THE

KATHARINE

ORDWAY

COLLECTION

INTRODUCTION BY ALAN SHESTACK

COMMENTARIES BY LESLEY K. BAIER

YALE UNIVERSITY ART GALLERY

NEW HAVEN · CONNECTICUT

Copyright © Yale University Art Gallery

Library of Congress Catalogue Card Number 82-051257

ISBN 089467-025-5

PUBLISHED BY YALE UNIVERSITY ART GALLERY

2006 YALE STATION, NEW HAVEN, CONNECTICUT 06520

FEBRUARY 1983

PREFACE AND ACKNOWLEDGMENTS

In 1980, Yale University received as a bequest Katharine Ordway's splendid art collection and a sizeable endowment for its maintenance and conservation, as well as a generous fund enabling our museum to make occasional new acquisitions in Miss Ordway's name. The present catalogue records Miss Ordway's gift and also includes the first work of art purchased with income from the Ordway Fund, the fine Stuart Davis illustrated on page 85. Most of the works of art on view in the new Katharine Ordway Gallery are illustrated in color in this book. The exhibition will eventually be changed as new works of art are gradually acquired with Miss Ordway's funds.

I want to express my sincere gratitude to the past and present members of the Yale Art Gallery staff who played an important part in the conception of the Ordway Gallery, its installation, or the preparation of this catalogue: James D. Burke, Mary G. Neill, and Richard S. Field. The Ordway Gallery was designed by Patrick Hickox and Brigit Williams, working with Richard Field, who was acting director at the time this design project was initiated. Special thanks must go to Robert C. Graham, a friend to both Miss Ordway and to the Yale Art Gallery. Raymond A. Carter has also been a friend and an inspiration. Mr. Carter was not only Miss Ordway's attorney, but her friend and advisor as well. As such, he has seen that her best interests were protected and we are all indebted to him.

The artists' biographies and the excellent interpretive essays on individual works of art in this catalogue were written by Lesley K. Baier, a doctoral candidate in Yale's History of Art program. Michael Komanecky, assistant to the Director, attended to many details of organization and production. The fine photographs were taken by Joseph Szaszfai and Geraldine Mancini. Greer Allen and John Gambell of the Yale Printing Service provided expert guidance; Howard Gralla designed the catalogue with his usual flair and distinction.

Most of all, I am grateful to Katharine Ordway, whose lifelong dedication to collecting art now benefits us all.

Alan Shestack, *Director*
Yale University Art Gallery

INTRODUCTION

K ATHARINE ORDWAY was a remarkable person. Her unassuming, even shy manner gave little evidence of her passion for the causes she espoused and supported, especially the preservation of beauty, both natural and man-made. She was a generous donor to the Nature Conservancy, the non-profit organization which acquires and preserves tracts of untouched land, and she created beautiful gardens on her own property. With equal devotion, she collected works of art. Except on rare occasions, it was not apparent to her visitors how much Miss Ordway enjoyed and treasured the objects which graced her walls. To anyone who knew her, however, it was clear that she collected art because she could not imagine living without it. Each acquisition was a personal choice, a commitment based on her own reaction to the character and quality of the object; her decisions never depended on the opinion of curators or critics or on the relative fame of the artist. Works of art from different times and places lived comfortably side by side in the agreeable ambiance of Miss Ordway's apartment in New York and in her gracious but unpretentious home in Weston, Connecticut. Though she cherished her collection, she lived easily in its company and never called attention to specific works, although she certainly had her favorites. Only when a guest exclaimed over the beauty of an especially luminous Rothko or a fabulous Pollock drawing would Miss Ordway's eyes sparkle as she nodded in shared appreciation. Hers was not, however, a collection formed to impress friends, but rather a group of paintings and sculptures acquired over many years, on a rather casual basis, whenever an item struck a responsive chord.

From the beginning of her collecting in the 1920s, Miss Ordway exercised her own judgment, showing remarkable independence and foresight. For instance, she saw Brancusi's *Mlle. Pogany* while it was still in the studio and bought it directly from the artist in 1925. Despite being teased by her older brothers for spending so much money on objects which must have seemed strange to them (to say the least), she knew her own mind.

7

Her handsome Gorky was purchased at a charity auction in 1949 purely for love of the picture, and her Pollock painting was bought from Betty Parsons in 1948, the year it was painted, long before Pollock became a household name. More often than not, Miss Ordway's intuitions were borne out by subsequent critical judgment.

It is hard to define a particular artistic style, attitude, or spirit which Miss Ordway admired especially; the collection ranges in mood from intimate Nabi paintings to giant gestural works by de Kooning. But one can understand why a true lover of nature might admire works as diverse as Burchfield's watercolors of eerie forests, Pollock's organically tangled skeins of paint, or Klee's symbolic allusions to the effects of changing seasons on the landscape.

Katharine Ordway was a major benefactor of the Yale University Art Gallery. The works of art she bought to enhance her own life will now be admired and studied by countless generations of students and will also be available for the public's enjoyment, as Miss Ordway wished.

A. S.

SELECTED WORKS

Commentaries by Lesley K. Baier

Notes to the Bibliographies:

Works cited in the General Bibliographies are listed alphabetically by author or institution. Short titles are included when the work is cited more than once.

In the exhibitions section of each entry, exhibitions are listed chronologically. Since virtually all works in this gallery were included in the exhibition of Miss Ordway's collection at the Saint Paul Art Center [Saint Paul Art Center, St. Paul, Minnesota. *The Katharine Ordway Collection* (intro. by Malcolm E. Lein), May 1968], that exhibition is referred to throughout as *Saint Paul Art Center, 1968.*

PIERRE-AUGUSTE RENOIR

A central figure in the history of French Impressionism, Auguste Renoir was concerned with variations in light and color not only as agents of fluctuating optical sensations but also as the means through which to express on canvas his exuberant delight in the sensual opulence of the world around him. Born in Limoges on 25 February 1841 and raised in Paris, he was apprenticed to a porcelain painting firm in 1854. At the École des Beaux-Arts, where he studied from 1862 to 1864, Renoir became a close friend of Claude Monet, Alfred Sisley and Frédéric Bazille, with whom he spent vacations painting out-of-doors at such sites as the Forest of Fontainebleau. He later participated in the first three Impressionist exhibitions (1874, 1876 and 1877) and, by 1879 was enjoying popular success as a portrait painter. Undaunted by a debilitating stroke in 1912, he continued to paint with brushes strapped to his arms and, in 1915, experimented briefly with sculpture. Renoir died at his home in Cagnes on 3 December 1919.

General Bibliography

Barnes, Albert C. and de Mazia, Violette. *The Art of Renoir*. Merion, Pennsylvania: The Barnes Foundation Press, 1935.

Daulte, François. *Auguste Renoir. Catalogue Raisonné de l'Oeuvre Peint*, vol. I (vols. II–IV forthcoming). Lausanne: Éditions Durand-Ruel, 1971.

Rouart, Denis. *Renoir* (tr. James Emmons). Geneva: Éditions d'Art Albert Skira, S.A., 1954.

Vollard, Ambroise. *La Vie et l'Oeuvre de Pierre-Auguste Renoir*. Paris: Ambroise Vollard, 1919.

Renoir, Pierre-Auguste
French, 1841–1919
Mont Sainte-Victoire (La Montagne Ste.-Victoire), 1889
Oil on canvas Signed lower right: Renoir
53.0 x 64.0 cm (20⅞ x 25¼ in)
1980.12.14

Provenance: Purchased from the Bignou Gallery, New York, 1941.
Exhibitions: *Saint Paul Art Center, 1968*, no. 58.

Friendships among the Impressionist artists often led them to frequent the same sites and occasionally even to set up their easels side-by-side. Renoir most likely painted this view of Mont Sainte -Victoire, a motif made famous by Paul Cézanne, during a visit to Cézanne at Aix-la-Provence in the summer of 1889.[1] Although the choice of subject was undoubtedly inspired by the older artist, Renoir's work bears no direct relationship to Cézanne's own paintings of the scene. In contrast to the latter's emphasis on structural solidity, broad brushstrokes and more sober greens and browns, Renoir dissolves mass and detail in a densely woven fabric of staccato brushstrokes whose bright colors and varying impasto stress surface pattern rather than volume. Even the impression of deep space implied by the diagonal recession of the trees is countered by the blaze of orange with which Renoir colors the supposedly distant ones on the left. The intensity of the light, in combination with the blurring effect of the brushstrokes, creates the effect of an atmospheric haze made vibrant by heat and glare. Ultimately, the density of Renoir's paint application contributes to a sense of airlessness that restricts the viewer's experience of the expansiveness of the landscape, substituting for it a multi-sensory reading of the scene as intensely bright, hot and dry.

1. Renoir painted at least one other view of the mountain that summer: *Mont Sainte-Victoire*, 1889: The Barnes Foundation, Merion, Pennsylvania.

References: Vollard, Ambroise, *Tableaux, Pastels et Dessins de Pierre-Auguste Renoir*, Paris, Ambroise Vollard, 1918, vol. I, no. 398, illus.

EDOUARD VUILLARD

Born in Cuiseaux on 11 November 1868, Edouard Vuillard studied briefly at the École des Gobelins and the École des Beaux-Arts before enrolling in the Académie Julian in 1888. There, he joined a small band of artists, including Paul Sérusier, Maurice Denis and Pierre Bonnard, in founding the Nabi movement. Inspired by the works of Gauguin and the Symbolists, the Nabis pursued an art of imagination and intimation, in which color and line played an expressive, evocative role independent of form and anecdote. Vuillard exhibited with the group from 1891 until its disbandment in 1896. Throughout the 1890s he was active as well in several other artistic arenas. Fascinated by the theatre, he designed program covers and stage sets for Lugné-Poë's Théâtre de l'Oeuvre; and as a printmaker working almost exclusively in lithography, he contributed to *La Revue Blanche* (published 1891–1903), an avant-garde review of the literary, dramatic and fine arts in Europe. After a decade of such diverse and innovative achievement, Vuillard's art grew increasingly conservative. By 1914 he had withdrawn from public exhibitions and was largely concerned with commissioned portraits of wealthy literary and artistic figures. Vuillard died at La Baule in Brittany on 21 June 1940.

General Bibliography

Preston, Stuart. *Edouard Vuillard*. New York: Harry N. Abrams, Inc., 1971.

Ritchie, Andrew Carnduff. *Edouard Vuillard*. New York: The Museum of Modern Art, 1954.

Roger-Marx, Claude. *Vuillard. His Life and Work* (tr. E.B. D'Auvergne). London: Paul Elek, 1946.

Russell, John. *Vuillard*. London: Thames and Hudson, 1971.

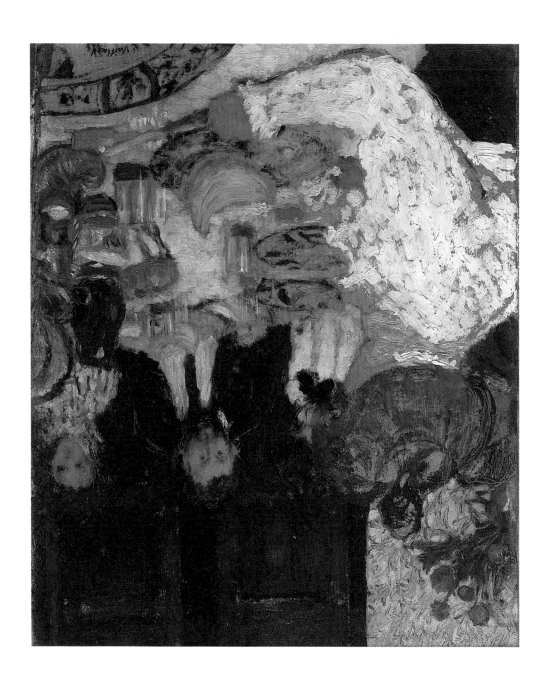

Vuillard, Edouard
French, 1868–1940
Le Déjeuner (The Luncheon), ca. 1895–97
Oil on cardboard Signed lower right: E Vuillard
40.0 x 35.1 cm (15¾ x 13¹³⁄₁₆ in)
1980.12.17

Provenance: H. Taeubler; Purchased from Jacques Seligmann and Co., New York, 15 February 1947.

Exhibitions: J. Seligmann and Co., Inc., New York, *Vuillard – His Dynamic Early Period*, 5–27 November 1948, no. 9; *Saint Paul Art Center, 1968*, no. 75, illus; Yale University Art Gallery, New Haven, *The Intimate Vision of Edouard Vuillard* (text by Elizabeth W. Easton), 10 September–26 October 1980, no. 4.

Vuillard's description of himself as an "intimiste" pertains both to his temperament and to the style and subject matter of his work of the 1890s. His paintings of that decade offer glimpses into the daily lives of his family and friends, engaged in such ordinary activities as reading, eating and sewing. But it is not the intimacy of Vuillard's choice of subject alone that accounts for the atmosphere of privacy in which these works seem steeped. In *Le Déjeuner*, through a combination of pattern, spatial compression, subdued tonal harmonies and a compositional arrangement whose seeming informality masks careful deliberation, he achieved a reciprocity between figure and setting that reinforces the work's hermetic, exclusionary aspect. The depth implied by the scale discrepancy between foreground and background figures is contradicted by Vuillard's treatment of the surface as a plane of interwoven line and color. His individually visible brushstrokes read as flat color patches rather than modelled forms; the orange of the woman's scarf is repeated in the melons and napkin rings; and the wallpaper echoes the pattern of the far right figure's dress. In addition, spatial extension is limited by the table, acting as a physical barrier in the foreground, and by the double doors, which form a flat, impenetrable screen behind three of the diners.

But the sense of closure in *Le Déjeuner* is far more subtly effected by the predominance of circular, and hence self-contained, configurations. Through scale and placement, Vuillard has deliberately given prominence to a partially seen plate in the lower right corner. Its curving rim implies the plate's full circumference and establishes a precedent for viewing the arc of seated figures as part of a closed, slightly elliptical circle. The resulting air of tight-knit self-absorption is further strengthened by the nuance of glance and gesture linking the woman in the foreground to the sole male diner. Although unidentified by Vuillard, they may be Thadée Natanson, a founder of *La Revue Blanche*, and his wife Misia, two of the artist's closest friends in the 1890s. The man's facial resemblance to Natanson is striking, and the setting of *Le Déjeuner* is similar in arrangement and decor to the Natanson's dining room as seen in several photographs by Vuillard himself.

GEORGES ROUAULT

Georges Rouault was born in Belleville, on the outskirts of Paris, on 27 May 1871. Apprenticed to a stained glass maker and repairer in 1885, he enrolled in night classes at the École Nationale des Arts Décoratifs and, in 1890, abandoned his apprenticeship to study full-time at the École des Beaux-Arts. There he was singled out for distinction by his instructor and early mentor, Gustave Moreau. Although Rouault valued his independence as an artist and never subscribed to the principles of any particular artistic movement, he was not wholly aloof from the Parisian art world. A founding member of the Salon d'Automne, established in opposition to the academicism of the existing salons, he exhibited there with the Fauves in 1905, five years before his first one-man show at the Galerie Druet. Encouraged by his dealer, Ambroise Vollard, he became a prolific printmaker. In the late 1920s, Rouault worked briefly as a set and costume designer for Diaghilev's Ballet Russe; and from 1903 until his death in Paris on 13 February 1958, he served as director of the Musée Gustave Moreau.

General Bibliography

Courthion, Pierre. *Georges Rouault*. New York: Harry N. Abrams, Inc., 1977.

Dyrness, William A. *Rouault: A Vision of Suffering and Salvation*. Grand Rapids, Michigan: William B. Eerdmans Publishing Co., 1971.

Soby, James Thrall. *Georges Rouault. Painting and Prints*. New York: The Museum of Modern Art, 1947.

Venturi, Lionello. *Rouault* (tr. James Emmons). Paris: Éditions d'Art Albert Skira, 1959.

Rouault, Georges
French, 1871–1958
Nude Torso from the Back, ca. 1906
Oil on paper adhered to canvas
72.4 x 57.8 cm (28 ½ x 22 ¾ in)
1980.12.10

Provenance: Unknown.

Exhibitions: *Saint Paul Art Center, 1968,* no. 62.

Based on a gouache study of about 1906 (*Nude Torso,* Art Institute of Chicago), *Nude Torso from the Back* is one of the few oils Rouault painted in the first decade of the twentieth century. Rejecting clarity of contour and finish in favor of irregular brushstrokes and scumbled patches of color, and evenness of lighting in favor of exaggerated chiaroscuro, Rouault contrasts the nude's almost palpable physicality to its personal anonymity. So close to the picture plane that its right arm and lower legs are cut off by the edges of the frame, the figure is nevertheless obscured by deep shadows around its head and lower right side. The density of these shadows, extending into an indefinite dark ground, renders uncertain the figure's sex and actions. At first, the muscularity implied by the heavy modelling suggests a male figure. But in light of Rouault's preoccupation in the early 1900s with the theme of prostitution, it seems more likely that this is a female nude: a prostitute reaching up to let her hair down while her client, like the viewer, watches from behind.

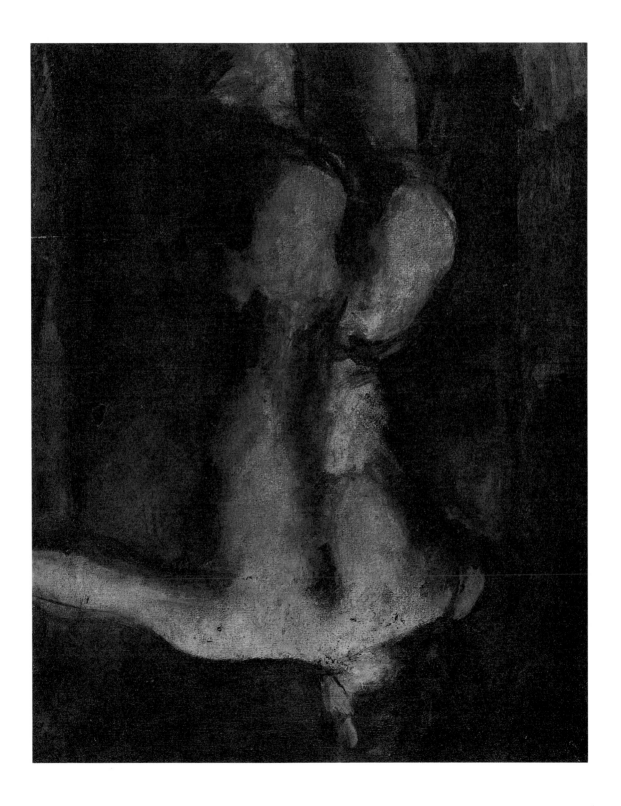

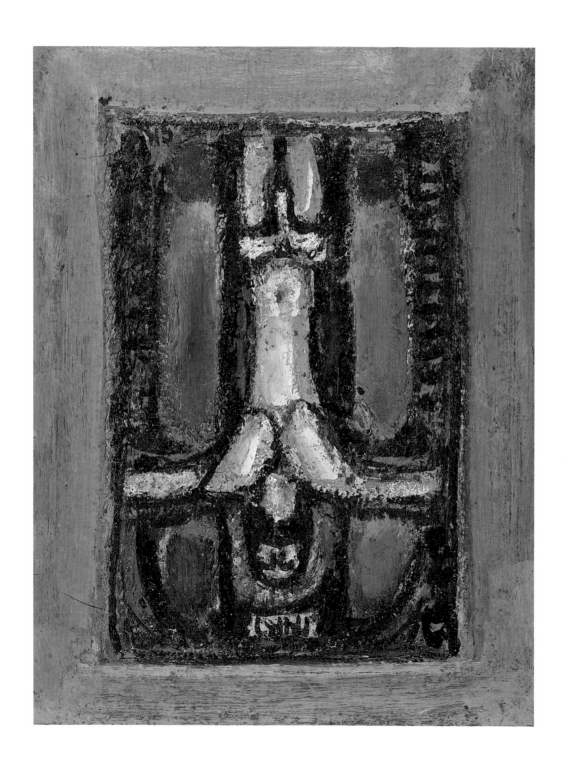

Rouault, Georges
French, 1871–1958
Crucifixion, ca. 1930–39
Oil on board Signed lower right: GR
40.3 x 30.2 cm (15⅞ x 11⅞ in)
1980.12.11

Provenance: Unknown.

Exhibitions: *Saint Paul Art Center, 1968,* no. 64, illus. in color.

A devout Catholic who felt out of step with twentieth-century artistic and moral values and who once claimed, "my real life is back in the age of the cathedrals,"[1] Rouault painted scenes from the Passion of Christ throughout his career. In style and format, *Crucifixion* is closely related to a group of paintings that Rouault executed in the 1930s, in conjunction with his etched and woodcut illustrations for André Suarès' *Passion* (published by Ambroise Vollard, 1939). That Rouault's mature style continued to reflect his early training in stained glass making is evident in the symmetrical frontality and flatness of the composition; the heavy encrustation of layered, jewel-like hues, in which shades of blue and red are dominant; and the use of black contour lines to separate forms. Unlike the majority of Rouault's Crucifixions, this work shows Christ without mourners, but with head raised in an attitude of communion with God. In keeping with his own deep faith in spiritual salvation, Rouault thereby emphasizes the promise of Christ's role as redeemer rather than the agony of His suffering as the victim of man's sins.

1. Quoted in James Thrall Soby, *Georges Rouault. Paintings and Prints* (New York: The Museum of Modern Art, 1947), p. 6.

PABLO PICASSO

In a career that spanned over eighty years, Pablo Picasso established himself as one of the most innovative and influential artists of the twentieth century. He was born in Málaga, Spain on 25 October 1881, the son of a modestly talented painter. In the early 1890s, he studied at local art schools in La Coruña and Barcelona and, in the fall of 1897, enrolled for several months in Madrid's Royal Academy of San Fernando. Anxious for the challenge of a more progressive artistic milieu, Picasso often sojourned in Paris from 1901 to 1903 and settled there permanently in April of 1904. Two years later he met Georges Braque, with whom he forged the Cubist style. The work of Picasso's middle years was particularly responsive to Surrealism, although he never formally joined that movement. Vastly prolific and amazingly versatile, he was active as a painter, sculptor, muralist, draughtsman, collagist, printmaker, ceramicist and set designer until his death in Mougins on 8 April 1973.

General Bibliography

Ashton, Dore, ed. *Picasso on Art: A Selection of Views*. New York: The Viking Press, 1972.

Barr, Alfred H., Jr. *Picasso. Fifty Years of his Art*. New York: The Museum of Modern Art, 1946.

Daix and Rosselet, 1979: Daix, Pierre and Rosselet, Joan. *Picasso. The Cubist Years, 1907–1916. A Catalogue Raisonné of the Paintings and Related Works* (tr. Dorothy S. Blair). Boston: New York Graphic Society, 1979.

Penrose, Roland and Golding, John, eds. *Picasso in Retrospect*. New York and Washington: Praeger Publishers, Inc., 1973.

Rubin, William, ed. *Pablo Picasso: A Retrospective*. New York: The Museum of Modern Art, 1980.

Zervos: Zervos, Christian. *Pablo Picasso*. [*Oeuvres de 1895–1972*], 33 vols. Paris: Éditions "Cahiers d'Art," 1932–1978.

Picasso, Pablo
Spanish, 1881–1973
Boy on Horseback, ca. 1905
Black chalk over pencil on machine laid paper
Signed upper right: Picasso
23.7 x 16.0 cm (9⁵⁄₁₆ x 6¼ in)
1980.12.28

Provenance: Daniel-Henry Kahnweiler, Paris.

Exhibitions: *Saint Paul Art Center, 1968*, no. 51.

Boy on Horseback is one of several drawings related to *The Watering Place*, an unrealized painting of Picasso's first "classic" period. The painting's composition was most fully worked out first in a gouache study (now in the Worcester Art Museum) and then in a drypoint which reversed the composition. Both works show a group of young, nude horsemen tending their mounts along the riverbank of a bare, gently rolling landscape. *Boy on Horseback* most likely derived from the horse and rider in the left foreground of the drypoint, differing significantly only in the positioning of the rider's arms. Rejecting the embellishments of both modelling and detail, Picasso suggests volume in the drawing solely through a masterful use of contour. His primary interest seems to have been to establish an organic relationship between the horse and bareback rider. The rider's leg curves subtly around the horse's belly, hugging its barrel-like dimensions; and his left hand, planted firmly on the horse's back, reinforces the effect of unambiguous solidity. But it is not, finally, such static balance alone that Picasso sought to reveal. The clenched fist is surely the sign of a contained power – of both man and beast – whose release is inevitable if not imminent. And the arch of the rider's back, exactly countering that of the horse's neck, implies a balanced interaction between mutually responsive wills.

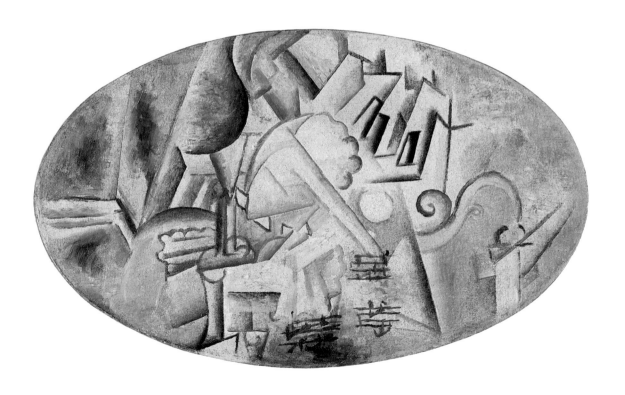

Picasso, Pablo
Spanish, 1881–1973
Coquillages sur un Piano (Sea Shells on a Piano), 1912
Oil on canvas Signed on verso: Picasso
24.1 x 41.0 cm (9½ x 16⅛ in) (oval)
1980.12.8

Provenance: Galerie Kahnweiler, Paris; Daniel-Henry Kahnweiler, Berlin; Edward von Saher, Amsterdam; Purchased from M. Knoedler & Co., Inc., New York, 18 June 1948.

Exhibitions: Hôtel Drouot, Paris, *1st Kahnweiler Sale*, 13–14 June 1921, no. 76; *Saint Paul Art Center*, 1968, no. 49.

Many of the formal and critical concerns that have dominated twentieth-century avant-garde art found their earliest expression in such Cubist works as Picasso's *Coquillages sur un Piano*, painted in the spring of 1912. Cubism rejected the traditional role of painting as a window on the world, exploded the accepted integrity of objects as self-contained closed forms, and challenged the sanctity of one-point perspective and veristic color. It asserted instead the incontrovertible flatness of the picture plane and hence, the painting's absolute independence as a work of art. This self-referentiality is reinforced here by Picasso's use of an oval frame, which counters our tendency to read the work as an extension of our own space. Within this frame, objects are rendered by discontinuous faceted planes, inconsistently illuminated from a myriad of sources. The interpenetration of foreground and background, solid and space, is so complex that single planes seem simultaneously transparent and opaque. In addition, the almost monochromatic scale of tones, from milky grey to black and from golden tan to sepia, acts as an equalizer of form and mitigates against a hierarchical reading of the space. This color scheme is interrupted only by the three touches of bright green on the left, whose inclusion serves to balance the more concentrated faceting and darker colors on the right.

But Picasso's pursuit of an art independent of perceived reality did not dissolve into pure abstraction. An insistent duality between painted shapes and their real world counterparts clearly informs our reading of *Coquillages sur un Piano*. The piano, chosen both for its immediately recognizable components and for its allusions to the Paris café scene of the 1910s, allowed Picasso to suggest an extra-artistic milieu through the most schematic of means. Its irregularly angled keys, emphatically prominent in the lower left, provide an initial sense of scale and spatial orientation. Other identifiable motifs include the candle in its scroll bracket, scalloped sea shells, musical bars, and the piano's upright back on the far right. Through shifts in tonality, Picasso implied but did not clarify the relationship of these objects in space. Rather, he deliberately substituted the dislocated fragment for the whole object, thereby emphasizing that the "whole" in his work was the work of art itself.

References: *Daix and Rosselet, 1979*, no. 461, illus.; Russoli, Franco and Minervino, Fiorella, *L'Opera completa di Picasso cubista*, Milan, Rizzoli Éditore, 1972, no. 446, illus.; *Zervos*, vol. 2¹, *Oeuvres de 1906 à 1912* (1942), no. 295, illus.

Picasso, Pablo
Spanish, 1881–1973
Femme Assise (Seated Woman), 1947
Oil on canvas Signed upper left: Picasso
99.9 x 80.7 cm (39 5/16 x 31 3/4 in)
1980.12.21

Provenance: Purchased from the Samuel Kootz Gallery, Inc., New York, 13 February 1950.

Exhibitions: Worcester Art Museum, Worcester, Massachusetts, *Picasso. His Later Works, 1938–1961* (Daniel Catton Rich, ed.), 25 January–25 February 1962, no. 23, illus.; The Art Gallery of Toronto, Toronto, *Picasso and Man* (cat. by Jean Sutherland Boggs with texts by John Golding, Robert Rosenblum and Jean Sutherland Boggs), 11 January–16 February 1964 (travelled to The Montreal Museum of Fine Arts, Montreal, 28 February–31 March 1964), no. 234, illus.; Washington Gallery of Modern Art, Washington, D.C., *Picasso since 1945* (text by Eleanor Green), 30 June–4 September 1966, p. 13, illus.; Samuel Kootz Gallery, New York, *Picasso: Paintings of 1947*, 26 January–14 February 1948, no. 2; *Saint Paul Art Center, 1968*, no. 50, illus. in color.

Picasso's fascination with woman in such multiple guises as idol, prostitute, model, victim and siren provides the thematic keynote to a significant part of his *oeuvre*. *Femme Assise* shares the playful exuberance of many of his late-forties paintings, an exuberance prompted as much by personal contentment as by the end of World War II. Painted in the early years of his affair with Françoise Gilot, it is one of several works in which she is portrayed as a flower. The duality of this metamorphosis, combined with variations in color and decorative detailing, enlivens the underlying symmetry of Picasso's frontal composition. One breast is a green leaf while the other is a small blue and yellow blossom; a triangular hand is paired with a rounded one; and the concave shape of Françoise's neck and head is contrasted to the convex stem of her body.

At first, this emphasis on flat, unmodulated colors and calligraphic line as pattern seems to contradict Picasso's interest in portraiture as a means of psychological revelation. Yet the iconic positioning of the figure, her calm,

mask-like features and the metaphor of woman as flower contribute to an enigmatic portrayal of Françoise as both a fragile object of devotion and a more hearty, imperturbably independent being. In this light, the white area encasing her figure seems to serve a double function. First, it is the throne upon which she regally sits. But in the frequent conflation of its outline with the contours of her own body, it also lends her figure a fullness associated with growth and blossoming. Painted just one month before the birth of their son Claude, *Femme Assise* may be a tribute as well to Françoise's pregnancy and impending motherhood.

References: Daix, Pierre, *La Vie de Peintre de Pablo Picasso*, Paris, Éditions du Seuil, 1977, p. 340, n. 13; *Zervos*, vol. 15, *Oeuvres de 1946 à 1953* (1965), no. 49, illus.

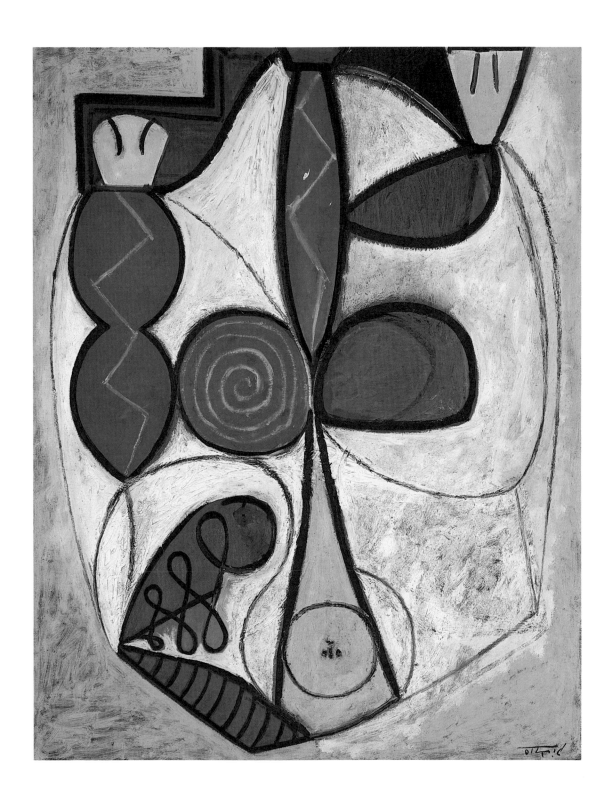

JUAN GRIS

Juan Gris' brief career as a painter (1911–1927) evolved wholly within the orbit of Cubism. The youngest of the leading members of that movement and one of its most articulate theoreticians, he was born in Madrid on 23 March 1887. Trained in industrial design at the Escuela de Artes y manufacturas (1902–1904), Gris supported himself as an illustrator for popular magazines while studying painting under José Maria Carbonero, a minor academic artist. In 1906, Gris emigrated to Paris where he moved in an artistic circle which included the writers Guillaume Apollinaire and Maurice Raynal, and the painters Picasso and Braque. Although his admiration for both of those artists was a determining factor in Gris' decision to become a painter, he never blindly imitated their achievements. Rather, he developed a distinctly personal style whose formal austerity and measured precision have earned him the appellation of "the purest" of the Cubist painters. Weakened by ill health throughout the 1920s, Gris died at Boulogne-sur-Seine, a Parisian suburb, on 11 May 1927.

General Bibliography

Cooper, Douglas. *Juan Gris. Catalogue raisonné de l'oeuvre peint*, 2 vols. (in collaboration with Margaret Potter). Paris: Berggruen Éditeur, 1977.

Gaya-Nuño, Juan Antonio. *Juan Gris* (tr. Kenneth Lyons). Boston: New York Graphic Society, 1975.

Kahnweiler, Daniel-Henry. *Juan Gris. His Life and Work* (tr. Douglas Cooper). New York: Harry N. Abrams, Inc., rev. ed., 1968 (orig. ed., 1946).

Soby, James Thrall. *Juan Gris*. New York: The Museum of Modern Art, 1958.

Gris, Juan
Spanish, 1887–1927
Still Life with Pipe, 1917–18
Watercolor, gouache and pencil on paper
Signed lower left: Juan Gris
29.2 x 23.3 cm (11 ½ x 9 ⅛ in)
1980.12.26

Provenance: Unknown.

A master of the still life, Gris devoted most of his art to developing a reper-
toire of shapes based on such motifs as bottles, bowls, glasses, pipes and
newspapers. *Still Life with Pipe* dates from his "architectural period"
(1916–20), when he was concerned with the process of composition and the
primacy of formal relationships. Its system of interlocking planes, empha-
sizing clarity of structure at the expense of simplicity of representation, was
carefully planned rather than fortuitously achieved. The preliminary
pencil outlines that establish the complete design were laid out according
to the Golden Section, a mathematical system of measurement whose
proportions ($a/b = b/a+b$) have been considered since classical times those
most harmonious to the eye. In addition, the work's diagonal axes, which
coincide with the edges and corners of key shapes, clearly served as a
compositional guide. Gris achieves an even tighter formal coherence
through a complex counterbalancing of light and dark planes and a subtle
repetition of shapes. The distribution of color on the left, where medium
and dark brown planes are ranged against a light brown ground, is re-
versed on the right, where light brown and white planes are set against a
medium brown ground. Similarly, the white shape of the horizontally
oriented pipe in the lower right quadrant is echoed in the dark brown
vertically oriented shape in the upper left quadrant.

Gris' unmodulated planes of color, emphasizing the flatness of the pic-
ture surface, are representationally ambiguous. The single exception is the

pipe, which retains its familiar contours and acts as a signpost to vantage point and scale. Prolonged examination of the work and familiarity with Gris' vocabulary of forms allow one to read the scroll-like pattern on the right as that of a cigarette package wrapper. The dark brown plane outlined in white in the lower center forms the base and stem of a glass. To suggest the transparency of this glass, Gris rendered the area of its bowl in two distinct planes: light brown on the left and unpainted paper on the right; in contrast to these recessive planes, the dark brown pipe-like shape to the left defines the space inside and around the glass as more solid than the glass itself.

In spite of the precision of its composition, *Still Life with Pipe* is by no means a mathematical exercise in sterile harmony. The viewer's attempt to determine logically consistent spatial relationships is undermined by color reversals that complicate the reading of overlapping planes. The background white of the paper, for example, ironically indicates the most "three-dimensional" objects: pipe and glass. In addition, Gris' avoidance of parallel, horizontal and vertical lines in favor of skewed diagonals contributes to a sense of spontaneous arrangement and dynamic tension.

CONSTANTIN BRANCUSI

Born in Hobitza in the Rumanian district of Gorj on 19 February 1876, Constantin Brancusi studied at the Craiova School of Arts and Crafts from 1895 to 1898, during his apprenticeship to a cabinetmaker, and at the Bucharest School of Fine Arts from 1898 to 1902. The following year, he left eastern Europe for the artistic mecca of Paris, where he settled permanently. Graduating in 1907 from the École des Beaux-Arts, he may have worked briefly that spring as an assistant in Rodin's studio. Although unaffiliated with any of the established movements in modern art, Brancusi won early widespread recognition as one of the foremost sculptors of his time. His first one-man exhibition, for example, was held in 1914 in New York at Alfred Stieglitz's Gallery of the Photo-Secession. Active until 1949, Brancusi produced major works in such diverse media as marble, plaster, wood and bronze. He died in Paris on 16 March 1957.

General Bibliography

Geist, 1968: Geist, Sidney. *Brancusi. A Study of the Sculpture.* New York: Grossman Publishers, 1968.

Geist, 1975: Geist, Sidney. *Brancusi. The Sculpture and Drawings.* New York: Harry N. Abrams, Inc., 1975.

Giedion-Welcker, Carola. *Constantin Brancusi* (tr. Maria Jolas and Anne Leroy). New York: George Braziller, Inc., 1959.

Jianou, Ionel. *Brancusi.* New York: Tudor Publishing Co., 1963.

Spear, Athena T. *Brancusi's Birds.* New York: New York University Press, 1969.

Brancusi, Constantin
French, b. Rumania, 1876–1957
Mlle. Pogany II, 1925
Polished bronze Signed near base at lower left: C. Brâncusi
H. 43.5 cm (17 ⅛ in)
1980.12.16

Provenance: Purchased from the artist in Paris, ca. 1925.

Exhibitions: *Saint Paul Art Center, 1968*, no. 7, illus.

Fascinated by the process of evolution, Brancusi repeatedly examined the same motifs in order to mine the possibilities of formal and technical variation and refinement. *Mlle. Pogany II* is the second in a series of three discrete yet evolutionary interpretations of a subject Brancusi had first treated in 1912. The original *Mlle. Pogany* derived from sketches and clay busts of Margit Pogany, an Hungarian artist who had posed for Brancusi in the winter of 1910–11. In the second and third versions, conceived in 1919 and 1931 respectively, Brancusi placed progressively greater emphasis on attenuated verticality and simplified formal elegance, thus moving the work farther away from the realm of actual portraiture into that of abstract, decorative design.

Our *Mlle. Pogany II*, cast by the artist in 1925, is one of four polished bronzes of the 1919 version. The mouth, eyes and chignon of the 1912 work have been replaced by accentuated arcing brows and an elongated, stepped swirl of arched curls. The arms and hands which, in the earlier sculpture, were held to the left cheek in an attitude of prayer, are now joined into a single tapering column. Brancusi's new, sparer design, with its precise contours and sharply defined but sinuous lines, establishes a rhythm of smooth transition between parts. In combination with the work's spiralling rather than frontal orientation, this rhythm invites the viewer to move around the sculpture. The resulting multiplicity of aspects is

reinforced by the highly polished surface which denies one's sense of mass and weight by reflecting light and mirroring the work's environment.

Mlle. Pogany II's contemplative pose, and the sacrifice of individually articulated features in favor of a more concentrated unity, suggest that Brancusi intended the work to represent the artist's muse, the source of his creative inspiration. The contained tranquility of the pose, complementing the sculpture's formal equilibrium, can thus be seen to symbolize Brancusi's conception of the creative act as a pursuit and revelation of inner essence rather than external appearance.

References: (includes only citations of this particular cast) *Geist, 1968*, no. 120c; *Geist, 1975*, no. 128c.

PAUL KLEE

Having merged fantasy and reality in works whose enigmatic meanings range from the whimsical to the grotesque, Paul Klee is often called a Surrealist although he was never actively affiliated with that movement. Born in Münchenbuchsee near Bern on 18 December 1879, he studied art in Munich from 1898 through 1901, first in a private art school run by Heinrich Knirr and then under Franz Stuck at the Academy. In 1912, he participated in the second Blaue Reiter exhibition and travelled to Paris, where he was particularly impressed by the work of Robert Delaunay. Invited by Walter Gropius to teach at the Bauhaus in 1920, Klee remained on the faculty until 1931 when he resigned to accept an instructorship at the Düsseldorf Academy. Ousted under the Nazi regime in 1933, he returned to his native Switzerland and died at Muralto-Locarno on 24 June 1940.

General Bibliography

Geelhaar, Christian. *Paul Klee and the Bauhaus*. Bath, England and Greenwich, Connecticut: New York Graphic Society, Ltd., 1973.

Giedion-Welcker, Carola. *Paul Klee* (tr. Alexander Gode). New York: The Viking Press, 1952.

Glaesemer, Jürgen. *Paul Klee. Die farbigen Werke im Kunstmuseum Bern (Gemälde, farbige Blätter, Hinterglasbilder und Plastiken)*. Bern: Kunstmuseum Bern, 1976.

Grohmann, Will. *Paul Klee*. New York: Harry N. Abrams, Inc., 1955.

Spiller, Jürg, ed. *The Notebook of Paul Klee*. vol. I: *The Thinking Eye* (tr. Ralph Manheim). London: Lund Humphries, 1961; vol. II: *The Nature of Nature* (tr. Heinz Norden). New York: George Wittenborn, 1973.

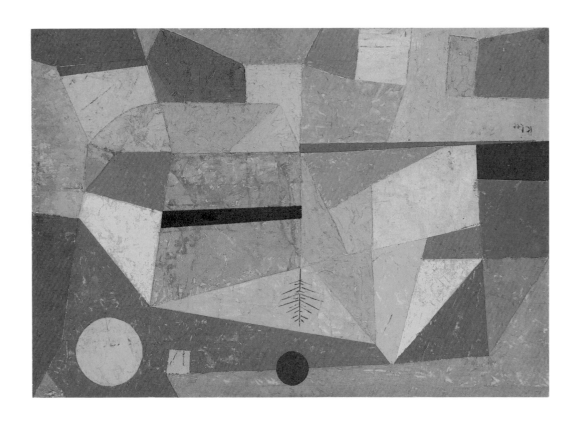

Klee, Paul
Swiss, 1879–1940
Joyful Mountain Landscape (heitere Gebirgslandschaft), 1929
Oil on board Signed left edge: Klee
43.9 x 63.1 cm (17⁵⁄₁₆ x 24⅞ in)
1980.12.22

Provenance: Purchased from the Nierendorf Gallery, New York, 1946.

Exhibitions: San Francisco Museum of Art, San Francisco, *Paul Klee Memorial Exhibition. Addenda to the Exhibition of The Museum of Modern Art*, 14 April–5 May 1941; Stendahl Art Galleries, Los Angeles, 8–18 May 1941; Washington Gallery of Modern Art, Washington, D.C., *Twentieth-Century Paintings from Connecticut Collections*, 17 September–24 October 1965; *Saint Paul Art Center, 1968*, no. 32, illus. in color.

Like most of Klee's architectonic landscapes of the 1920s, *Joyful Mountain Landscape* is composed of rectilinear color planes whose literal flatness and divergent edges defy traditional perspectival recession. Yet the atmospheric luminosity that Klee sought in much of his work has eluded him in this oil painting. Although he juxtaposed the complementary colors red/green, blue/orange and yellow/violet, his planes of color are neither subtly modulated nor spatially illusionistic. Hard-edged and discrete by virtue of their incised outlines, they achieve the barest atmospheric reverberation. Indeed, it is only the undercoat of salmon pink, shimmering through the roughly scraped layers of surface color, that lends the work a degree of textural, if not spatial, translucency.

Joyful Mountain Landscape does contribute, however, to an understanding of two themes central to Klee's *oeuvre*: the relationship between time and change, and the opposition of dream to reality. The painting is divided into three roughly horizontal bands signifying earth, mountains and sky. Having established this underlying trinity, however, Klee seems intent on challenging its implied permanence. The mountains, represented by triangles and trapezoids, defy the horizontal earthbound planes

and strain towards the infinity of the cosmos above. More pointedly, the presence of a leafless tree, the opposition of summery green to autumnal oranges, and the inclusion of both a diurnal sun and nocturnal moon combine to suggest temporal and seasonal conflations. Thus, a setting sun links day with night and casts a final brilliant glow over a darkening landscape. Similarly, a full, perhaps harvest moon, signalling the autumnal equinox, reinforces the idea that Klee is here concerned with the seasonal transition from summer to autumn.

In related fashion, Klee injects elements of fantasy and the unexpected into this work's somewhat labored geometry. The title, clarifying his thematic intentions, ascribes to the mountains the human emotion of joy. Hence, it calls attention to their soaring ascent as a metaphor for man's spiritual aspirations. The incongruous placement of a tiny house in the upper right, a somewhat modest castle in the air, further celebrates spiritual liberation from physical bonds and illumines Klee's position as an artist of the imaginary as well as the real.

References: Grohmann, Will, "Paul Klee und die Tradition," *Bauhaus zeitschrift für gestaltung*, 3 (December 1931), unpag., illus.; Martin, J.L., Nicholson, Ben and Gabo, Naum, *Circle. International Survey of Constructive Art*, New York and Washington, Praeger Publishers, 1971 (orig. publ. 1937), no. 38, illus.; Read, Herbert, *Art Now: an introduction to the theory of modern painting and sculpture*, New York, Toronto and London, Pitman Publishing Corp., rev. ed., 1960, illus., no. 150.

PIERRE BONNARD

Pierre Bonnard was born at Fontenay-aux-Roses, near Paris, on 3 October 1867. Briefly enrolled at the École des Beaux-Arts in 1888, he transferred to the Académie Julian where Édouard Vuillard and Maurice Denis were fellow students. The three artists shared a studio from 1889-90 and, with Paul Sérusier, founded the Nabi movement in 1891. Heralding Gauguin as their mentor, the Nabis dedicated themselves to an art of subjective allusion rather than literal description. Bonnard exhibited with the group until 1894 and, two years later, was given his first one-man exhibition at the Paris gallery of Durand-Ruel. Active also as a lithographer and set designer, Bonnard gradually withdrew from the Parisian art scene in the early 1910s, spending most of his time in the south of France. In 1939 he settled permanently at his villa in Le Cannet, where he died on 23 January 1947.

General Bibliography

Dauberville, 1965: Dauberville, Jean and Henry. *Bonnard. Catalogue Raisonné de l'Oeuvre Peint*, 4 vols. Paris: Éditions J. & H. Bernheim-Jeune, 1965.

Fermigier, André. *Pierre Bonnard*. New York: Harry N. Abrams, Inc., 1969.

Rewald, John. *Pierre Bonnard*. New York: The Museum of Modern Art, 1948.

Soby, James Thrall and Wheeler, Monroe. *Bonnard and His Environment*. New York: The Museum of Modern Art, 1964.

Terrasse, Antoine. *Bonnard* (tr. Stuart Gilbert). Geneva: Éditions d'Art Albert Skira, 1964.

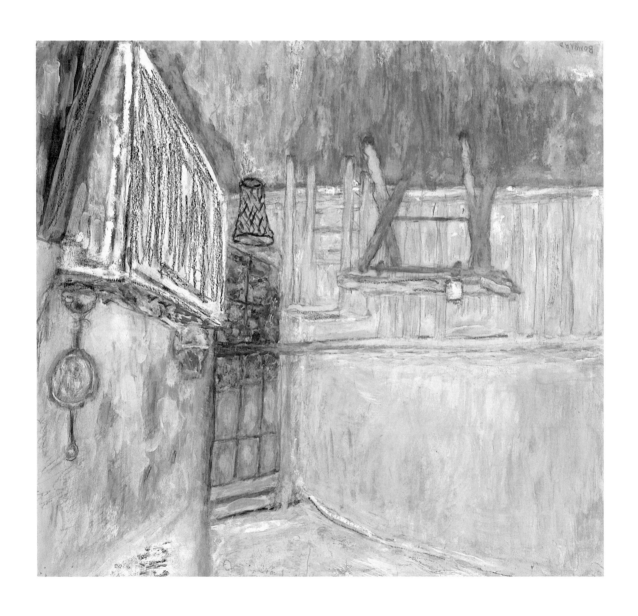

Bonnard, Pierre
French, 1867–1947
Interior with Table and Sideboard, ca. 1942–44
Gouache and black chalk on paper Signed lower left: BONNARD
43.5 x 47.5 cm (17 ⅛ x 18 ¾ in)
1980.12.20

Provenance: Purchased from Parke-Bernet Galleries, Inc., 10–11 December 1947.

Exhibitions: *Saint Paul Art Center, 1968*, no. 6.

Interior with Table and Sideboard is probably a view of Bonnard's studio at Le Cannet. It may well be related to a series of gouache studies in a similar style from which Jacques Villon executed a set of ten color lithographs in the early 1940s. The room's furnishings include a yellow drafting table, white stool, wire wastebasket, white and grey sideboard holding a jar and lamp and, in the lower right corner, a dark blue canvas and stretcher propped against the wall. Yet these objects seem incidental to Bonnard's fascination with spatial ambiguity and textural color. Pattern is emphasized at the expense of representational clarity. Perspectival distortion suggests that of a wide-angle camera lens: floor and ceiling are both visible, walls seem to curve inwards, and the sideboard's diagonals converge far too rapidly. This confusion of space is most pronounced at the far corner of the room where a French window and garden vista are seen through an open doorway. Although the base of this doorway seems flush with the room's rear wall, its diagonal upper edge implies that it joins that wall at an oblique angle. Similarly, the French window appears to recede along a diagonal, yet it is simultaneously held parallel to the picture plane by its central horizontal bar, which is continuous with the dado.

Bonnard's palette, though not as varied as one might expect in such a late work, harmoniously combines both rich saturation and exquisite nuance. Although initially captivated by the mustard yellow spilling across the floor and by the contrasting blue-greens and orange-reds of the garden, the viewer may just as easily lose himself in the softer, scumbled pale pinks, yellows, whites and greys of the walls.

49

Bonnard, Pierre
French, 1867–1947
Interior at Le Cannet, 1938, retouched 1943
Oil on canvas Signed lower right: Bonnard
126.4 x 125.1 cm (49¾ x 49¼ in)
1980.12.19

Provenance: Purchased from the Bignou Gallery, New York, 26 December 1946.

Exhibitions: Bernheim-Jeune, Paris, *34 peintures de Pierre Bonnard*, 15 June–13 July 1946, no. 33; *Saint Paul Art Center, 1968*, no. 4.

Like many of Bonnard's late works, *Interior at Le Cannet* combines intimacy of subject with exuberance of color. Painted at Le Bosquet, Bonnard's villa in the south of France, and inspired by his own domestic situation, it is one of a series of works showing his wife, Marthe de Méligny, at her toilet. Although Marthe's notoriously obsessive self-absorption may have informed not only Bonnard's choice of subject but also its enclosed, exclusionary presentation, it is the immediately gratifying sensuousity of brilliant color rather than frustrated voyeurism that ultimately characterizes the work.

Bonnard has divided *Interior at Le Cannet* into asymmetrical vertical zones describing three separate, incompletely seen spaces. To the left of center, an open door, arranged at right angles to the picture plane so that only its wallpapered edge and doorknobs are visible, establishes a continuous seam down the canvas. Separating the darkened area of the bath from the bright dressing room, it also marks the viewer's proximity to the scene. On the right, a second vertical defined by the mauve curtain and chair sets off a glass doorway that looks out over a balcony and garden. Eliminating all opportunity for horizontal extension, these vertical divisions subvert the implied spaciousness of the scene's three-part view and contribute to Bonnard's emphasis on two-dimensional pattern.

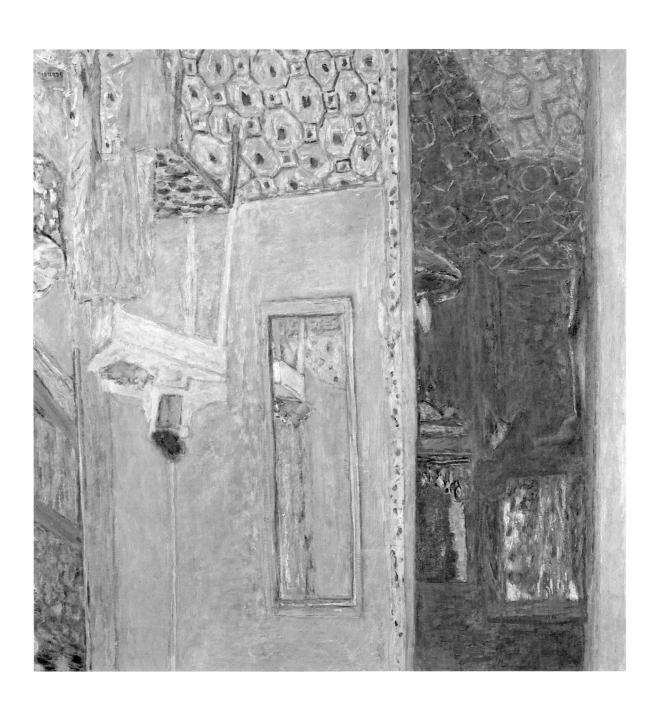

Tilting the floor planes up and avoiding diagonals that would clearly establish three-dimensional recession, Bonnard further complicates the viewer's reading of spatial relationships. Floors and walls seem to share a common plane; and the structural relationship of the bath to the dressing room is deliberately ambiguous. It is impossible to determine whether the door is hinged directly to the rear wall of the dressing room or to a second, unseen wall. Similarly, it is uncertain whether the bath's green and yellow tiled floor is continuous with or separate from the dressing room's white, pink, blue and orange floor tiles.

Bonnard's vivid colors and fractured brushstrokes create a richly sensuous surface. Individual color notes, like the brilliant blue of the tissues above the white table, or the three primaries of the confetti-patterned chair seat, serve as irresistible visual magnets. Objects themselves are disguised in a shimmering atmosphere of color patches. Thus, the elongated, bird-like nude, bent at the waist with arms clasped to her breast, is so intimately fused with her surroundings that she is often overlooked by the casual observer.

The colored fabric of Bonnard's painting that delights the viewer's eye also hangs curtain-like between him and the scene depicted. As a barrier to access, it reinforces the hermetic nature of Bonnard's subject and his directional emphasis on corners and edges. The abrupt contrast between the darkened green and mauve bath and the bright yellow dressing room not only underlines the difference between their functions but also suggests the artist's, or the viewer's, relation to the scene. Seeming to recreate the moment of his arrival when, dazzled by the sunlit glare of the dressing room, he is unable to adjust his sight to the shadowed recess beyond, it clearly labels him a trespasser into this private domain.

References: *Dauberville, 1965,* vol. III, *1920–1939,* no. 1564, illus.; Natanson, Thadée, *Le Bonnard Que Je Propose, 1867–1947,* Geneva, Pierre Cailler, 1951, no. 87, illus.

ARSHILE GORKY

The American artistic ferment of the 1940s, a decade that witnessed the transition from Surrealist-inspired theories and practices to the distinctly American style of Abstract Expressionism, owes much to the work of Arshile Gorky. Born Vosdanik Manoog Adoian on 15 April 1904 in Khorkom, in the Armenian province of Van, Gorky fled the Turkish invasion of his country in 1915 and emigrated to the United States five years later. A student at the New School of Design in Boston from 1922 through 1924, he enrolled in New York's Grand Central School of Art in 1925 and held a teaching position there until 1931. From 1935 to 1941, he worked on the mural division of the WPA's Federal Art Project. It was not until the early 1940s that Gorky, a passionate student of modern art, freed himself from a twenty year stylistic and thematic "apprenticeship" to Cézanne, Picasso and Miró. Tragically, the subsequent emergence of his own mature style was accompanied by a series of personal crises, including a devastating studio fire in 1946 and, in 1948, an automobile accident that left his painting arm paralyzed. On 21 July 1948, Gorky committed suicide in his Sherman, Connecticut studio.

General Bibliography

Jordan and Goldwater, 1982: Jordan, Jim M. and Goldwater, Robert. *The Paintings of Arshile Gorky: A Critical Catalogue*. New York and London: New York University Press, 1982.

Rand, Harry. *Arshile Gorky. The Implication of Symbols*. Montclair, New Jersey: Allanheld, Osmun and Co., Publ., Inc. and Abner Schram Ltd., 1981.

Reiff, Robert F. *A Stylistic Analysis of Arshile Gorky's Art from 1943-1948*. New York and London: Garland Publishing, Inc., 1977.

Rubin, William. "Arshile Gorky, Surrealism and the New American Painting," *Art International*, VII (25 February 1963), pp. 27–38.

Schwabacher, Ethel K. *Arshile Gorky*. New York: The Macmillan Co., 1957.

Guggenheim, 1981: The Solomon R. Guggenheim Museum, New York. *Arshile Gorky 1904–1948. A Critical Retrospective* (text by Diane Waldman), 24 April–19 July 1981.

Gorky, Arshile
American, b. Armenia, 1904–1948
The Betrothal, 1947
Oil on canvas Signed lower left: A Gorky 47
128.9 x 101.6 cm (50¾ x 40 in)
1980.12.45

Provenance: Donated by the artist to the International Rescue Committee, Inc., New York, January 1948; purchased at auction from the International Rescue Committee, Inc., New York, 4 April 1949.

Exhibitions: *Saint Paul Art Center, 1968*, no. 22, illus.; *Guggenheim, 1981*, no. 200, illus. in color (mentioned in text, p. 58).

It was in the 1940s, under the influence of his association with such Surrealist émigrés as André Breton and Mattà, that Gorky began to loosen his approach to painting by combining greater technical spontaneity and more autobiographical subject matter. This new and complex relationship between process and content, so crucial to an understanding of Gorky's position in the history of modern art, is subtly revealed in *The Betrothal* of 1947. The painting is one of a series that includes two additional finished oils (*The Betrothal I,* 1947: Collection of Mr. and Mrs. Taft Schreiber; and *The Betrothal II,* 1947: New York, Whitney Museum of American Art) and numerous preparatory studies. It is in Gorky's elaboration of the surface, including choice of color and relative opacity of paint, that the three Betrothals differ most radically. Yale's painting is the most optically transparent. Its thin grey washes, staining the canvas in irregular patches and meandering drips, focus attention on the picture's surface while simultaneously creating an illusion of shallow, indeterminate space. Overlapping the edges of Gorky's figures, this grey atmosphere softens their linearity and precludes the absolute separation of figure and ground. Bare canvas defining areas within these figural outlines further emphasizes the ambiguity of figure/ground relationships.

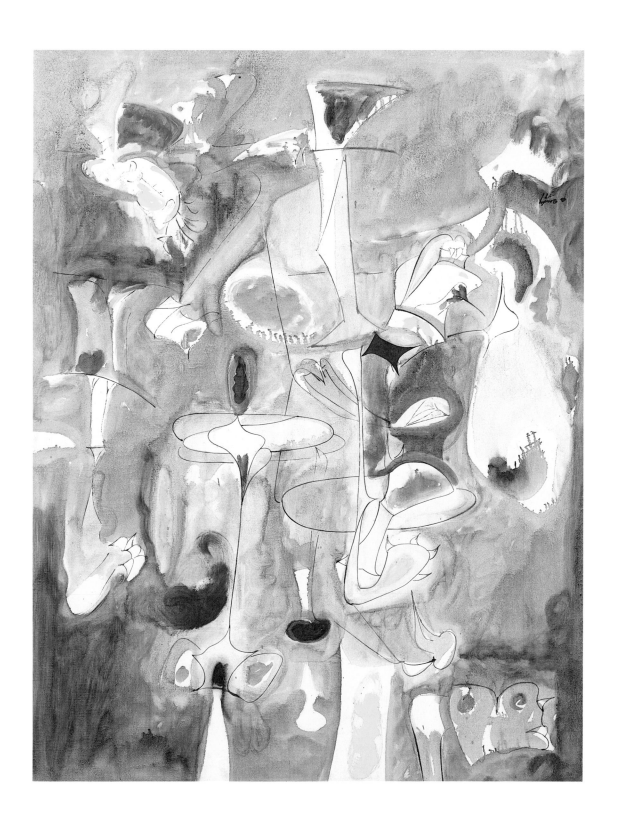

Gorky's celebration of the painterly surface clearly anticipated the concerns of the Abstract Expressionists. Yet he continued to assert as well the enigmatic content so dear to the Surrealists. The figures in *The Betrothal* are based on a highly personal morphology of shapes. The most prominent is the bride, wearing the traditional Armenian wedding crown and accompanied by several attendants and the small figure of the groom in the lower right corner. The fact that these figures assume an almost identical configuration in all three paintings lends them the impact of both reiteration and, by implication, obsession. Clearly, Gorky's primary concern is emotional and psychological revelation rather than superficial anecdote. The taut quality of his lines, which often seem stretched to the snapping point, suggests a barely contained tension made even more compelling by the disturbing irresolution of the figures and their vaporous surroundings. Gorky's title, as well as his insistent formal allusions to breasts and genitalia, suggest that this tension is predominantly sexual. Indeed, two figures on the right, the bug-eyed female attendant spinning top-like above her prominent genitalia, and the aroused male attendant who appears to walk a tightrope towards her, address the issues of balance and control in relation to obviously sexual encounters. Similarly, the almost insignificant, squashed figure of the bridegroom may allude to Gorky's own situation in a then foundering marriage.

References: *Jordan and Goldwater, 1982*, no. 340, illus. in color.

JACKSON POLLOCK

Heralded by many as the preeminent figure in the coming-of-age of American art, Jackson Pollock was the first of the Abstract Expressionists to win critical acclaim. Born in Cody, Wyoming on 28 January 1912, he studied from 1930 through 1933 at the Art Students League in New York, where Thomas Hart Benton was his primary instructor. Like many of his fellow artists, Pollock joined the Federal Art Project of the WPA in 1935 and was supported by that program until its demise in 1943. That year, he was given his first one-man show at Peggy Guggenheim's Art of This Century gallery in New York. Pollock turned to the "poured paint" technique of his mature style in 1947 and, over the next six years, produced the works for which he is best known today. Long a victim of alcoholism, whose control over his life was intensified by the demands of success, Pollock died in an automobile accident near his home in East Hampton, Long Island on 11 August 1956.

General Bibliography

Friedman, B.H. *Jackson Pollock: Energy Made Visible*. New York: McGraw-Hill Book Co., 1972.

MOMA and L.A. County Museum, 1967: The Museum of Modern Art, New York. *Jackson Pollock* (text by Francis V. O'Connor), 5 April–4 June 1967; Los Angeles County Museum of Art, 19 July–3 September 1967.

O'Connor and Thaw, 1978: O'Connor, Francis Valentine and Thaw, Eugene Victor. *Jackson Pollock: A Catalogue Raisonné of Paintings, Drawings, and Other Works*, 4 vols. New Haven and London: Yale University Press, 1978.

Rose, 1980: Rose, Bernice. *Jackson Pollock: Drawing into Painting*. New York: The Museum of Modern Art, 1980.

Rubin, William. "Jackson Pollock and the Modern Tradition," *Artforum*, V (February 1967), pp. 14–22; (March 1967), pp. 28–37; (April 1967), pp. 18–31; (May 1967), pp. 28–33.

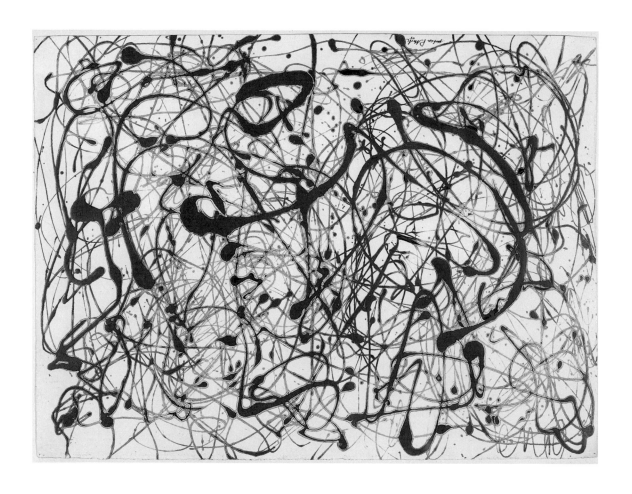

Pollock, Jackson
American, 1912–1956
Number 14: Gray, 1948
Enamel on gesso on wove paper
Signed lower left: Jackson Pollock 48
57.8 x 78.8 cm (22¾ x 31 in)
1980.13.74

Provenance: Probably purchased from the Betty Parsons Gallery, New York, 1949.

Exhibitions: Betty Parsons Gallery, New York, 24 January–12 February 1949; The Museum of Modern Art, New York, *Jackson Pollock* (text by Sam Hunter), 19 December 1956–3 February 1957, no. 12, illus.; Museo de arte moderna, São Paulo, *IV Bienal: Pollock* (text by Sam Hunter), 22 September–31 December 1957, no. 18; Marlborough-Gerson Gallery, New York, *Jackson Pollock* (text by Bryan Robertson), January–February 1964, no. 90; *MOMA and L.A. County Museum, 1967,* no. 140, illus. (mentioned in text, p. 45); *Saint Paul Art Center, 1968,* no. 56; The Solomon R. Guggenheim Museum, New York, *Twentieth-Century American Drawing: Three Avant-Garde Generations* (text by Diane Waldman), 1976, no. 91.

Pollock's poured paint process offered a radical solution to the dilemma of spatial illusionism in modern art. Dispensing with the figure, and hence with traditional figure/ground relationships, it gave to line and support equal roles in the creation of optical, rather than representational space. *Number 14: Gray* is a striking example of the optical, tonal and textural richness that Pollock often achieved through subtle variations in this process. The work consists of black enamel paint poured onto a paper support which was pre-coated with a wet gesso (plaster of Paris) ground. Each stream of paint bled into this damp, chalky surface, creating the delicately feathered grey borders with black edges that surround each line and pool of black enamel. In contrast to the linear core of black enamel, whose denser surface seems to project towards the viewer, these more transparent greys are recessive. Inseparably wed to both line and ground, like haloed traces of an atmospheric disturbance, they contribute to an over-

whelming sense of spatial ambiguity and vibration. The tightly curved arcs of paint, organized around a central vertical, seem to deny the flatness of the picture plane as they weave optically in and out of space. Gaining in intensity as they widen, and in implied velocity as they narrow, these skeins of paint bear witness to Pollock's dynamism even as they are softened, absorbed and transformed by the gesso ground.

References: Berkman, Florence, "Show Contrasts Modern Art Trends," *Hartford Times*, (12 January 1957), illus.; Eversole, Finley, review in *Theology Today* (July 1968), p. 268; Getlein, Frank, "Brushless Painting of Jackson Pollock," *Milwaukee Leader* (30 December 1956), illus.; Gombrich, E.H., *The Story of Art*, 11th ed., London, Phaidon Publishers, 1966, p. 457, illus.; Kepes, Gyorgy, *The Nature and Art of Motion*, New York, George Braziller, 1965, p. 6, illus.; *O'Connor and Thaw, 1978*, vol. II, no. 204, illus.; O'Hara, Frank, *Jackson Pollock*, New York, George Braziller, 1959, illus., pl. 30; Prossor, John, "An Introduction to Abstract Painting," *Apollo*, 66 (October 1957), p. 83, illus.; Robertson, Bryan, *Jackson Pollock*, New York, Harry N. Abrams Inc., 1960, p. 172, illus.; *Rose, 1980*, p. 7, 9, illus. (not in exhibition); Rose, Bernice, *Jackson Pollock: Works on Paper*, New York, The Museum of Modern Art in association with The Drawing Society, Inc., 1969, p. 67, illus. (not in exhibition).

Pollock, Jackson
American, 1912–1956
Number 4, 1949
Oil, enamel and aluminum paint with pebbles on cut canvas on
composition board Signed lower center: Jackson Pollock 49
90.5 x 87.3 cm (35⅝ x 34⅜ in)
1980.12.6

Provenance: Purchased from the Betty Parsons Gallery, New York, 13 December 1949.

Exhibitions: Betty Parsons Gallery, New York, *Jackson Pollock, Paintings,* 21 November–10 December 1949; The Museum of Modern Art, New York, *Jackson Pollock* (text by Sam Hunter), 19 December 1956–3 February 1957, no. 16; Museum Friedericianum, Kassel, *Documenta II* (text by Sam Hunter), 11 July–11 October 1959, no. 5; *MOMA and L.A. County Museum, 1967,* no. 35 (mentioned in text, pp. 48, 75); *Saint Paul Art Center, 1968,* no. 55, illus.; Katonah Gallery, New York, *American Painting, 1900–1976* (text by John I. Baur), 29 May–18 July 1976; Musée national d'art moderne, Centre Georges Pompidou, Paris, *Jackson Pollock* (texts by Dominique Bozo et al.), 19 January–10 May 1982, illus. in color, p. 168 (travelled to Städelsches Kunstinstitut und Städtische Galerie, Frankfurt, 1 June–31 July 1982.)

In contrast to the chromatic abstractions of Mark Rothko, in which paint seems optically translucent rather than physically layered, Jackson Pollock's *Number 4* is linear in execution and richly tactile in effect. Freed from its traditional role as figural or geometric outline, Pollock's line calls attention instead to both materials and process. It marks the varied trajectories of paint that has been poured or spattered directly onto the canvas, without the medium of brush or palette knife. Line, paint, color and gesture are thus wholly coextensive, radically synthesized into a single, unprecedented autonomy.

In *Number 4,* an underlying network of paint skeins whose projecting, cord-like thickness paradoxically counters their role as "background," crosses the work in slightly oblique horizontals. Over these, the pools and rivulets of black, white and aluminum paint are predominantly vertical in orientation. Despite this underlying structural organization, it is the

surface complexity of the work that Pollock emphasizes. This complexity is apparent not only in the intricacy of Pollock's interweaving lines, but also in his inclusion of gravel and pebbles and his use of three types of paint. Oil paint is matte-like in comparison to the glossy enamel and the reflective aluminum paint.

The sheer density of *Number 4*'s surface draws the viewer close to the work, inviting him to focus on a piecemeal inspection of details. In many ways, such extreme encrustation destroys the spatial opticality that characterizes Pollock's best works. Because the lateral edges of the painting have been trimmed, indicating that Pollock salvaged this work from an initially larger one, they are as densely painted as the central areas; unlike the top and bottom edges, where the paint thins out and the canvas support is frequently visible, they do not allow for the illusion of expansion against the framing edges that Pollock often achieved. This very density, however, contributes to *Number 4*'s exquisitely contained dynamism. Pollock's lines of paint swell and taper so subtly in response to his controlled gestures that they create a sense of implied movement and imminent change. The aluminum paint further intensifies this effect; shimmering faintly in dim light and sparkling like quicksilver in full sun, it is so sensitive to its surroundings that the experience of *Number 4* varies infinitely with the time of day and the quality of the light.

References: Bayl, Friedrich, "Jackson Pollock," *Die Kunst und das Schone Heim*, IX (June 1961), p. 333, illus.; Haryu, Ichiro, ed., *Art Now*, vol. X, Japan, Kodansha Ltd., 1972, p. 16, illus. in color; *Kunstwerk, Das*, 13, nos. 2-3 (August–September 1959), p. 45, illus.; *O'Connor and Thaw, 1978*, vol. II, no. 249, illus.; O'Hara, Frank, *Jackson Pollock*, New York, George Braziller, 1959, illus., pl. 38.

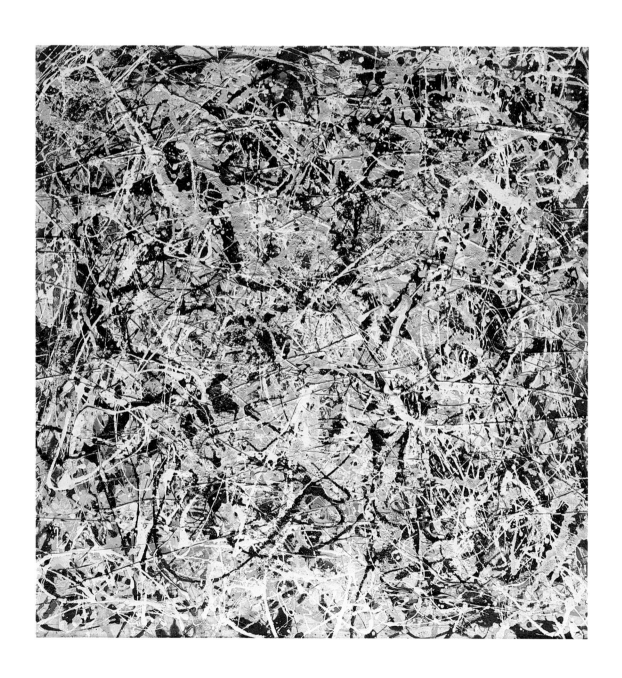

CHARLES BURCHFIELD

Most often associated with the literary and artistic school of American Regionalism, Charles Burchfield was celebrated in his own time – as he is today – as an artist of the neglected contemporary American scene. He was born in Ashtabula Harbor, Ohio on 9 April 1893 and studied at the Cleveland School of Art from 1911 to 1916. Wholly unexposed there to recent developments in European avant-garde art, he was particularly drawn to the decorative character of such diverse works as Oriental scroll painting; costume and set designs for the Ballet Russe by the Russian painter, Léon Bakst; and book illustrations by Arthur Rackham. In 1916 Burchfield, who valued artistic independence above theoretical and technical instruction, gave up a scholarship to New York's National Academy of Design after one day in its life drawing class. Five years later he moved from Ohio to Buffalo, New York, where he worked as a wallpaper designer for H.M. Binge and Sons until 1929, when he resigned to devote himself to painting. He died on 10 January 1967, one month after the opening of the Charles Burchfield Center in Buffalo.

General Bibliography

Baigell, Matthew. *Charles Burchfield*. New York: Watson-Guptil Publications, 1976.

Baur, John I.H. *Charles Burchfield*. New York: The Macmillan Company, 1956.

——. *The Inlander: The Life and Work of Charles Burchfield, 1893–1967*. E. Brunswick, New Jersey: University of Delaware Press, 1981.

Trovato, Joseph S. *Charles Burchfield. Catalogue of Paintings in Public and Private Collections*. Utica: Museum of Art, Munson-Williams-Proctor Institute, 1970.

Burchfield, Charles
American, 1893–1967
Marsh in June, 1952–56
Watercolor on wove paper
Signed with monogram lower right: C V B 1952–56
88.4 x 65.6 cm (34½ x 25¹³⁄₁₆ in)
1980.13.65

Provenance: Unknown.

With the exception of brief experimentations in etching and oil painting, Burchfield worked almost exclusively in watercolor. In his earliest works, he concentrated on a highly imaginative interpretation of nature's many moods, developing a series of shorthand, linear notations, which he called "Conventions for Abstract Thoughts," to express pictorially such emotions as fear, brooding and melancholy. In the late 1920s, Burchfield abandoned these dream-like fantasy landscapes in favor of a more realistic evocation of mid-Western small-town life. Not until the early 1940s, in hopes of regaining the spontaneity of his early work, did he return to the unadulterated landscape as subject. Acutely sensitive to the most subtle climatic and seasonal variations, he rejected a minute inventory of visual details in favor of suggesting nature's motive forces.

In *Marsh in June,* the dominant impression of heat and humidity, of heavy stillness broken only by the hum of insect wings, is articulated by the insistently downward pull of the broad, undulating brushstrokes. The subdued palette of thinly washed grey-blues, grey-greens and pale mauves, countered only by a narrow zone of more saturated rusts and greens along the bottom edge of the work, reinforces this sense of atmospheric heaviness and gravitational force. Varying his brushstrokes only in color, not orientation, Burchfield blurred distinctions between forms and forced the viewer to respond instead to the expressive effects of linear and coloristic pattern.

MARK ROTHKO

Within the mainstream of the movement known generally as Abstract Expressionism, Mark Rothko more specifically represents the stylistic sub-group concerned with color rather than line. Born Marcus Rothkovich in Dvinsk, Russia on 25 September 1903, he was ten when his family emigrated to Portland, Oregon. An undergraduate at Yale in the early 1920s, Rothko studied intermittently under Max Weber at New York's Art Students League from 1925 to 1926. In the late 1930s, influenced by Surrealist theories of art as an expression of the unconscious mind, he developed a vocabulary of biomorphic forms which, by 1950, evolved into the color field abstractions of his mature style. Rothko achieved considerable critical success within his own lifetime and, in 1961, was honored with a major travelling retrospective organized by The Museum of Modern Art. His most important commission, a black and maroon colored series on the Passion of Christ for the Rothko Chapel in Houston, was not dedicated *in situ* until 1971, one year after his suicide in New York on 25 February 1970.

General Bibliography

Fuller, Robert Fulton. *A Critique of Criticism: The Mature Paintings of Mark Rothko* (Ph.D. dissertation, The University of North Carolina at Chapel Hill, 1974). Ann Arbor: Xerox University Microfilms, 1974.

Kozloff, Max. "The Problem of Color-Light in Rothko," *Artforum*, IV (September 1965), pp. 38-44.

Seldes, Lee. *The Legacy of Mark Rothko*. New York: Holt, Rinehart and Winston, 1978 (1974).

Selz, Peter. *Mark Rothko*. New York: The Museum of Modern Art, 1961 (catalogue of an exhibition that travelled internationally through January 1963).

Guggenheim, 1978–79: The Solomon R. Guggenheim Museum, New York. *Mark Rothko, 1903–1970. A Retrospective* (text by Diane Waldman), 27 October 1978–14 January 1979; The Museum of Fine Arts, Houston; Walker Art Center, Minneapolis; Los Angeles County Museum of Art, Los Angeles.

Rothko, Mark
American, b. Russia, 1903–1970
Untitled, 1954
Mixed media on unprimed canvas
Signed on verso lower right: Mark Rothko 1954
235.5 x 142.7 cm (93 x 56³⁄₁₆ in)
1980.12.24

Provenance: Purchased from the Marlborough-Gerson Gallery, Inc., New York, 1972.

Exhibitions: *Guggenheim, 1978–79,* no. 119, illus. in color.

Rothko, Mark
American, b. Russia, 1903–1970
No. 3, 1967
Mixed media on unprimed canvas
Signed on verso lower right: MARK ROTHKO / 1967
205.1 x 193.0 cm (81 x 75¹⁵⁄₁₆ in)
1980.12.23

Provenance: Purchased from the Marlborough-Gerson Gallery, Inc., New York, 30 January 1968.

Exhibitions: *Saint Paul Art Center, 1968,* no. 61; *Guggenheim, 1978–79,* no. 186, illus. in color.

Mark Rothko's mature works share a deliberately limited structure of rectangles or squares arranged in loose vertical sequences. Yet within this repeated format, they explore an infinite range of exquisite color harmonies and proportional relationships. Whether overlapped and juxtaposed in pairs of vivid color opposites, as in the orange/blue and purple/yellow of *Untitled,* or in subtly close values, as in the deep oranges, reds and maroons of *No. 3,* these colors vibrate with an unprecedented luminosity.

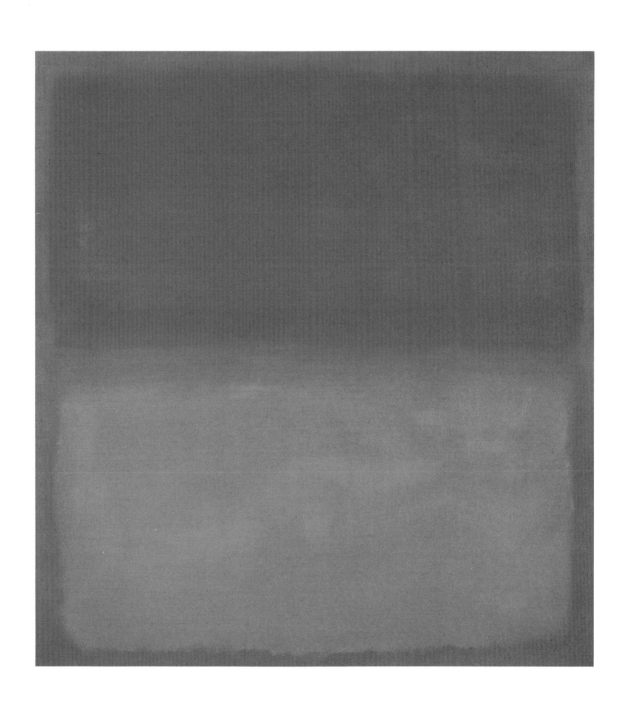

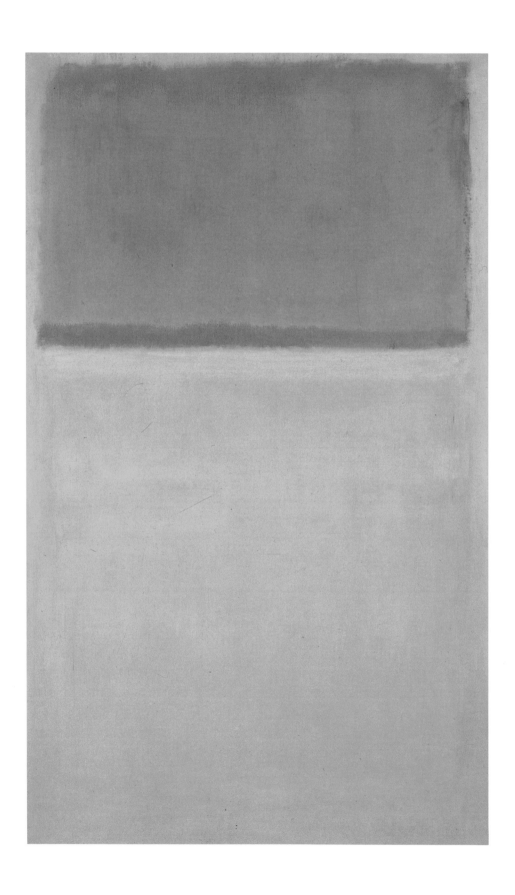

Color acts as both space and light, achieving an effect analogous to that of the diffused, colored light that streams through stained glass windows.

Clearly the optical translucency of Rothko's colors is intimately dependent on his painting technique. Each layer of brushed or poured paint soaks into the unprimed canvas, resulting in a radical dissolution of traditional distinctions between figure, ground and support. In *Untitled*, touches of reds and yellows emerge faintly through the pinkish orange of the upper rectangle, while the purple-blue in the lower zone is but an insubstantial veil over the rich reds and oranges glowing through it. The scumbled edges of these rectangles contribute as well to Rothko's complex merging of foreground and background into an indeterminate, atmospherically illusionistic space. In contrast to the bright and varied palette of *Untitled*, the deeper, more somber colors of *No. 3*, characteristic of Rothko's late work, initially seem more opaque. The nuances of its color modulations resist the cursory glance.

In comparison to the kinetic energy of Jackson Pollock's paintings, Rothko's work is more calmly lyrical. Its intensity is that of meditation rather than activity; and its sensuousity is more purely optical than tactile. Like all of the Abstract Expressionists, Rothko celebrated painting as a revelation of the self, a metaphor for the artist's inner emotional and psychological state. Yet he was concerned as well with the viewer's share in this art of subjective expression. Suggesting that his paintings be viewed close-up and in dim light, he hoped to immerse the spectator in the color itself. To Rothko, the immediacy of such an encounter, in which the viewer and the object seen are implicitly united, echoed in part his own intimate relation to the work as its creator.

WILLEM DE KOONING

Of the leading Abstract Expressionists, only Willem de Kooning refused to abandon figuration as a legitimate subject for modern art. His figures themselves often derived from images of American popular culture; and, as a result, de Kooning is recognized as a key mediator between earlier American artistic traditions, Abstract Expressionism and Pop Art. Born in Rotterdam on 24 April 1904, he took night classes at the Rotterdam Academy of Fine Arts and Techniques from 1916 to 1925, while working at a commercial art firm. In 1926, de Kooning emigrated to the United States where he supported himself as a commercial artist, house painter and carpenter until 1935, when he decided to become a full-time painter. He worked briefly for the WPA, began a career-long exploration of the female figure as a dominant motif in 1938 and, ten years later, was given his first one-man show at the Charles Egan Gallery in New York. De Kooning, who experimented as well with both sculpture and lithography in the late 1960s and early 1970s, continues to paint at his studio of twenty years in The Springs, East Hampton.

General Bibliography

Hess, Thomas B. *Willem de Kooning.* New York: George Braziller, Inc., 1959.

——. *Willem de Kooning.* New York: The Museum of Modern Art, 1968.

Rosenberg, Harold. *de Kooning.* New York: Harry N. Abrams, Inc., 1974.

Guggenheim, 1978: The Solomon R. Guggenheim Museum, New York. *Willem de Kooning in East Hampton* (text by Diane Waldman), 10 February–23 April 1978.

de Kooning, Willem
American, b. Holland 1904
Untitled, No. 2, ca. 1957–65
Oil, paper towels and cigarette butt on newspaper mounted
on board Signed lower left: de Kooning
68.3 x 51.0 cm (27 ¼ x 20 ⅝ in)
1980.12.30

Provenance: Purchased from the Robert Keene Gallery, Southhampton, 1965.

Exhibitions: *Saint Paul Art Center, 1968,* no. 18.

De Kooning's interest in abrupt discontinuities of color, texture and shape informed his use of collage in the 1950s and early 1960s. In *Untitled, No. 2,* the flat, grey, rectilinear patterns of the newspaper support are antithetical to the brightly colored paint and diagonally aligned, roughly textured paper towels that animate its surface. It might be argued, moreover, that the newspaper provides an analogue for the Cubist grid system, whose scaffolding dominated most twentieth-century Western painting until the advent of Abstract Expressionism. De Kooning's superimposition of freer, all-over brushstrokes contradicts the newspaper's rigid uniformity and points to the supremacy of the later movement. The paper towels, cigarette butt and brushwork purposefully transgress the lower edges of the newspaper, breaking its otherwise strict and potentially constraining geometry. Similarly, the paint itself varies considerably in appearance and effect, in contrast to the more regularized pattern of the newsprint. In the upper half of the work, the paint scuds thinly across the paper in shades of rose, cream and blue. In the lower half, complementing the heaviness of the creased towels, it is more thickly daubed in a wider range of colors, like the paint on an artist's palette.

De Kooning's choice of the medium of collage extends the range of his historical comment on the relationship between Cubism and Abstract Expressionism. Cubist collages often emphasized problems internal to the creation of art, as for example, the contradiction between spatial illusionism and the flatness of the picture plane. De Kooning's *Untitled, No. 2* addresses this tradition in its opposition of the flat and the painterly, but, closer to the spirit of Dada, focuses primarily on the actual incorporation of life into art. Newspapers, paper towels and cigarettes, ordinarily the detritus of the artist's studio, paradoxically become part of his creative output. At the same time, however, de Kooning clearly asserts the artist's ultimate control over his materials. The newspaper, one of the most significant items of daily life, is upended; its text is obscured and the crucial touchstone of its full publication date is obliterated. De Kooning has not only salvaged the dispensable, but rendered timeless the temporal.

In a further play on the relationship between art and life, de Kooning seems to have left one telling portion of the newsprint legible. Along the center right edge appears the following caption:

Sen. Jacob K. Javits
Target of smear campaign.

Above the caption, a photograph of Javits is dimly visible through a "smear" of peachy white paint. Such a facetious literalization of the word in paint could hardly have been fortuitous.

de Kooning, Willem
American, b. Holland 1904
Untitled XIII, 1975
Oil on canvas Signed on verso, lower center: de Kooning
220.5 x 195.5 cm (87 ¼ x 77 in)
1980.12.7

Provenance: Purchased from the artist through Fourcade, Droll Inc., New York, after 1975.

Exhibitions: Fourcade, Droll Inc., New York, *De Kooning: New Works – Paintings and Sculpture*, 25 October–6 December 1975, no. 13, illus. in color; *Guggenheim, 1978*, no. 32, illus. in color.

Untitled XIII of 1975 demonstrates de Kooning's unequivocal commitment to the lush, painterly surface. Although the combined impact of scale, aggressively gestural brushstrokes and shocking hues initially keeps the viewer at a distance, the richness of the surface ultimately encourages close-up examination of the work. The inevitability of this shift in vantage point is but one indication of the delicate balance de Kooning was able to achieve between the bold and subtle, the monumental and intimate.

De Kooning's delight in extravagant surface complexity finds unlimited expression in *Untitled XIII*. Like most of his paintings, it is heavily reworked. Broad, irregular strokes abruptly change direction or come to a sudden stop as they slash across earlier, more evenly painted areas. There is no easy transition between shapes or colors; rather, juxtapositions are deliberately discontinuous and jarring. At the same time, de Kooning's preference for reworking while the paint was still wet allowed him to create transparent passages within seemingly opaque swashes of paint. These passages suggest an optical depth that complements the literal tactility and textural range of the paint itself. The out-of-focus "ribbon roll" along the lower right edge is thinly squeegeed across the canvas, looking more like a translucent veil than solid pigment. At the opposite extreme, the intense blues and the bright orange to the right of center are thickly rippled in patterns like those of mountain ranges on relief maps. While any given

painting was in progress, de Kooning would cover it with newspapers to keep the paint from drying between working sessions. Here, that process left a clear imprint on the white paint at center left, serving not only as an additional surface modulation but also as a telling witness to the artist's fascination with the accidental as a significant factor in the creative process.

Despite the immediacy of paint as surface, *Untitled XIII* also possesses an elusive structure of emerging and dissolving "images." De Kooning's reluctance to establish clearly the existence of these figures articulates a deliberate tension between the tactile qualities of paint and the illusionistic potential of the brushstroke. Even more disquieting are the unexplained clashes between areas of somber grey and those of wild, carnival-like pinks, blues and fuchsias. Such dualities have long been central to de Kooning's art. Less grotesque but equally unsettling, *Untitled XIII* is clearly the heir to de Kooning's voluptuously colored but savagely fragmented, searing images of women.

References: Ratcliff, Carter, "Willem de Kooning: New Paintings and Sculptures," *Art International*, XIX (20 December 1975), pp. 14, 73, illus. in color (incorrectly on its side).

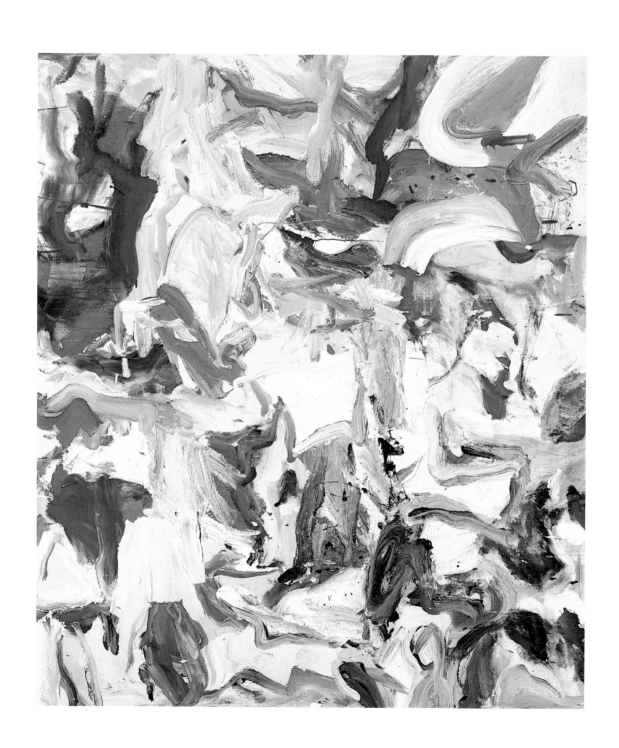

STUART DAVIS

Stuart Davis was one of the few American artists to accomodate his life-
long fascination with the American scene to a sophisticated understanding
of the principles of Synthetic Cubism. Born in Philadelphia on September
or December 7, 1892 or 1894, he enrolled in 1909 in Robert Henri's art
school, the most progressive American one of its time. There he was en-
couraged to make New York street scenes his subject and to paint with a
spontaneity and liveliness appropriate to the tempo of modern life. From
1913 to 1916, Davis worked on the art staff of the socialist periodical, *The
Masses*. The following year, he had his first one-man show at the Sheridan
Square Gallery in New York. With the exception of a year in Paris (1928–29),
Davis divided most of his time between New York and Gloucester, Massa-
chusetts. Much acclaimed in the 1930s for his WPA sponsored murals, he
taught at the New School for Social Research from 1940 through 1950 and
was given his first major retrospective by The Museum of Modern Art in
1946. Davis died in New York on 24 June 1964.

General Bibliography

Brooklyn Museum and Fogg Art Museum, 1978: The Brooklyn Museum, New York. *Stuart
Davis. Art and Art Theory* (text by John R. Lane), 21 January–19 March 1978; Fogg Art
Museum, Cambridge, 15 April–28 May 1978.

Goossen, E.C. *Stuart Davis*. New York: George Braziller, Inc., 1959.

Kelder, Diane, ed. *Stuart Davis*. New York: Praeger Publishers, 1971.

Sweeney, James Johnson. *Stuart Davis*. New York: The Museum of Modern Art, 1945.

Davis, Stuart
American, 1892/4–1964
Schwitzki's Syntax, 1961–64
Oil and wax emulsion and masking tape on canvas
106.7 x 142.2 cm (42 x 56 in)
1980.84

Provenance: Estate of the Artist through Grace Borgenicht Gallery, New York, May 1980.

Exhibitions: The Metropolitan Museum of Art, New York, *New York Painting and Sculpture: 1940–1970* (text by Henry Geldzahler), October 1969–February 1970, p. 132, illus.; Lawrence Rubin Gallery, New York, *Stuart Davis: Major Drawings on Canvas and Paper from 1928 to 1964,* January–March 1971; *Brooklyn Museum and Fogg Art Museum, 1978,* no. 86, illus.

Never a pure abstractionist, Davis drew inspiration from contemporary subject matter and intended his paintings, or "Color-Space-Compositions," as he called them, to "celebrat[e] the resolution in art of stresses set up by some aspects of the American scene."[1] In *Schwitzki's Syntax,* the last in a series of three paintings nominally inspired by a matchbook cover advertisement for Champion brand spark plugs,[2] it is through vigorous interplay of colors and shapes, exciting auditory as well as optical sensations, that Davis captured the spirit of dynamism and exuberance he admired in modern American life. Adopting the bold directness of American advertising art in particular, he emblazoned the dominant motif – the word "champion" – billboard-like across the canvas. He thus forces the viewer to read across the surface, to examine the work's lateral rather than perspectival extensions in space. Rejecting volumetric modelling and tonal gradations in favor of vibrant contrasts of black to white and red to green, Davis creates a collage-like effect of flat, irregularly cut and overlapping shapes whose impact is loud, abrupt and assertive.

Schwitzki's Syntax, like many of Davis' titles, is enigmatic and open to speculative interpretation. "Syntax," defined broadly as the systematic organization or arrangement of component parts into a unified whole,

here suggests the painter's role as manipulator of pictorial elements into a cohesive composition. In his Notebook entries for 1923, Davis had defined a painting in terms of these elements as "a collection or complex of colored tones of definite shape and size, that is all."[3] Seen in such a context, "Schwitzki" is perhaps an alias for Davis himself. A play on the word "switch," it calls attention to the painting as a re-exploration of a previously developed motif and thus to Davis' pursuit of a new pictorial order through variation of syntax. Such an interpretation is reinforced by Davis' inclusion of an ampersand [&] and a modified symbol for variation [ઠ] at the top of the painting, implying that the underlying compositional device is inexhaustible and open to unlimited modification.[4] Finally, Davis' role as both manipulator of media and arranger of forms is strikingly asserted by the incongruous presence of a strip of masking tape across the otherwise painted work. Originally meant only as a temporary guideline for dividing the canvas into horizontal quadrants, the tape literalizes Davis' allusions to the art of collage and raises questions about the relationship between process and intent.

1. Quoted in *Brooklyn Museum and Fogg Art Museum, 1978*, p. 30.
2. Cf. *Little Giant Still Life*, 1950: Richmond, Virginia Museum of Fine Arts; and *Visa*, 1951: New York, The Museum of Modern Art.
3. Quoted in Diane Kelder, ed., *Stuart Davis* (New York: Praeger Publishers, 1971), p. 47.
4. In *Visa*, Davis had employed the word "Else" in similar fashion, claiming that its "fundamental dynamic content . . . consist[ed] of the thought that something else [was] possible . . ."Quoted in Kelder, p. 101.

References: National Collection of Fine Arts, Smithsonian Institution, Washington, D.C., *Stuart Davis Memorial Exhibition, 1894–1964* (introduction by H.H. Arnason), 28 May–5 July 1965, p. 49 (not in exhibition); "Review [of Davis exhibition at the Lawrence Rubin Gallery]," *The New York Times*, 14 February 1971, sec. 2, p. 23.

CATALOGUE

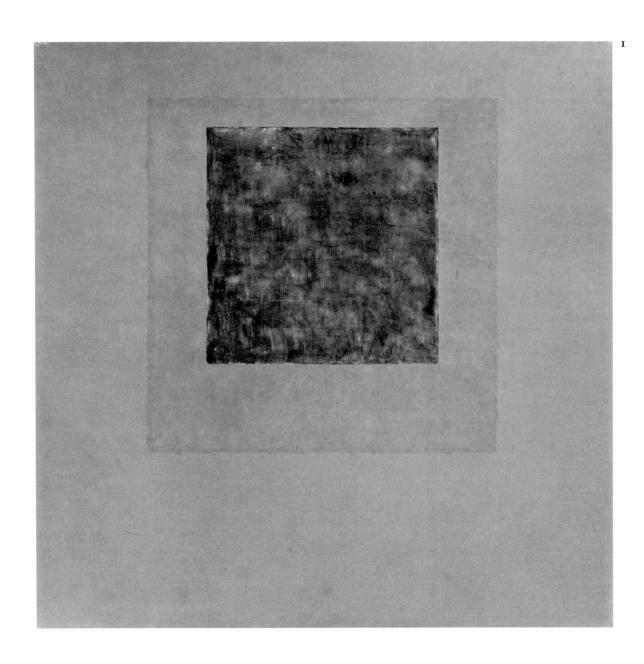

AMERICAN ART

Albers, Joseph, b. Germany
(1888–1976)
1 **Homage to the Square: "Saturated"**
1951
Oil on masonite
59.4 x 59.2 cm (23⅜ x 23⁵⁄₁₆ in)
1980.12.39

Bertoia, Harry, b. Italy (1915–1978)
2 **Abstract,** ca. 1961–67
Bronze wire garden sculpture
95.0 x 38.0 cm (37½ x 15¼ in)
1980.13.43

Biala, Janice (b. 1903)
3 **Duet**
Pencil and chalk
34.7 x 42.5 cm (13¹¹⁄₁₆ x 16¾ in)
1980.13.33

Burchfield, Charles (1893–1967)
4 **Marsh in June,** 1952–1956
Watercolor
88.4 x 65.6 cm (34½ x 25¹³⁄₁₆ in)
1980.13.65 [color section]

Burchfield, Charles (1893–1967)
5 **September in the Woods,** 1957
Watercolor
68.3 x 100.4 cm (26⅞ x 39½ in)
1980.12.40

Calder, Alexander (1898–1976)
6 **Mobile**
Painted sheet metal and steel wire,
black and red wires with red, yellow,
blue, black and white plates
55.8 x 119.2 cm (22 x 47 in)
1980.13.45

Calder, Alexander (1898–1976)
7 **Mobile,** 1957
Red wires and red plates
91.3 x 237.4 cm (36 x 93½ in)
1980.12.41

Calder, Alexander (1898–1976)
8 **Stabile,** 1943
Black wire and black plates on wire
base
114.2 x 86.2 cm (45 x 34 in)
1980.12.42

Callahan, Kenneth (b. 1907)
9 **Mice Playing,** 1960 (?)
Pen, brush and ink
34.5 x 50.5 cm (13⅝ x 20 in)
1980.13.46

Callahan, Kenneth (b. 1907)
10 **Forest Interior,** 1956 (or 1958?)
Pen and ink wash
61.0 x 91.3 cm (24¹⁄₁₆ x 36 in)
1980.13.48

Callahan, Kenneth (b. 1907)
11 **Cascade Mountain Scene,** 1953 (?)
Pen, brush and ink
48.5 x 63.5 cm (19⅛ x 25 in)
1980.13.47

Davies, Arthur B. (1862–1928)
12 **Morning Quiet,** 1920
Lithograph
37.5 x 28.2 cm (14¾ x 11 in)
1980.13.67

2

5

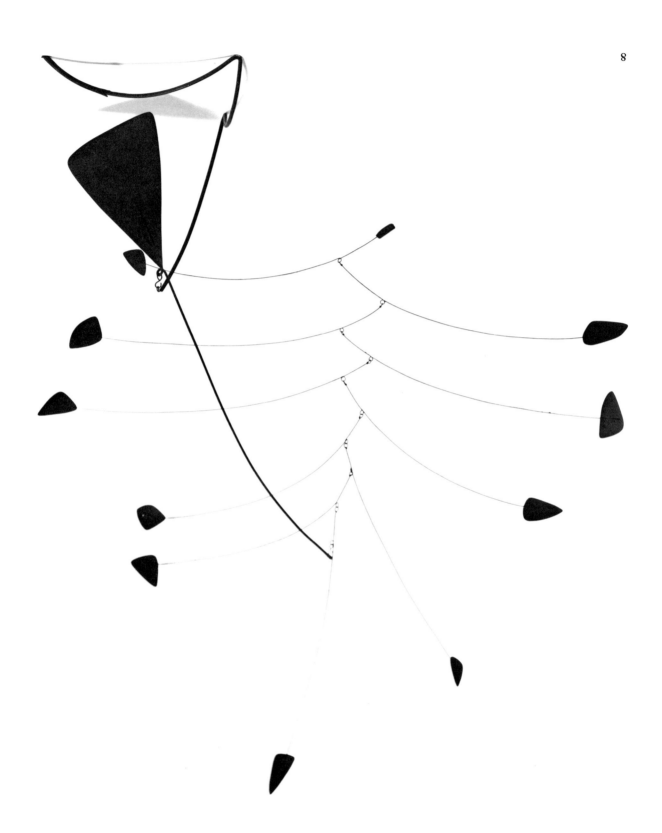

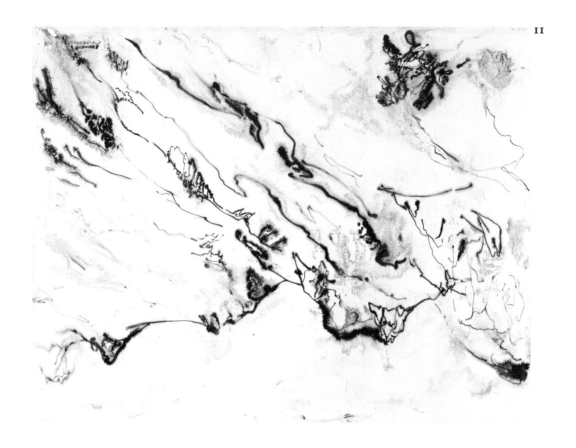

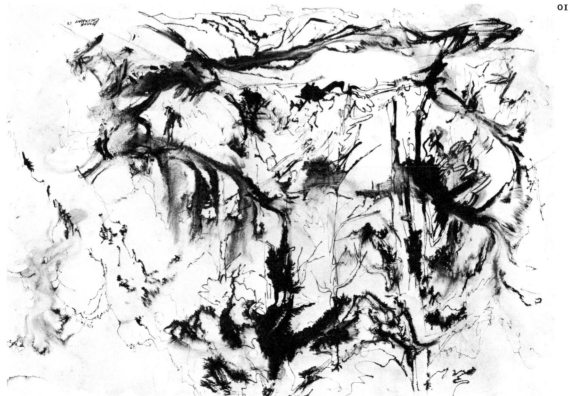

Davies, Arthur B. (1862–1928)
13 **Olympic Game,** 1920
Lithograph
31.9 x 44.8 cm (12⁹/₁₆ x 17⁵/₈ in)
1980.13.69

Davies, Arthur B. (1862–1928)
14 **Release at the Gates,** 1923
Color lithograph
29.7 x 42.2 cm (11⁵/₈ x 16⁵/₈ in)
1980.13.68

Davies, Arthur B. (1862–1928)
15 **Woodland Spring,** 1920
Lithograph
45.4 x 32.3 cm (17⁷/₈ x 12¹¹/₁₆ in)
1980.13.70

Davis, Stuart (1892/4–1964)
16 **Schwitzki's Syntax,** 1961–64
Oil and wax emulsion and masking
tape on canvas
106.7 x 142.2 cm (42 x 56 in)
1980.84 [color section]

Diebenkorn, Richard (b. 1922)
17 **Conversation**
Oil on canvas
35.3 x 29.2 cm (13⁷/₈ x 11½ in)
1980.12.43

Diebenkorn, Richard (b. 1922)
18 **The Drinker,** 1957
Gouache over pencil
42.5 x 35.4 cm (16¾ x 13⁷/₈ in)
1980.12.44

Gorky, Arshile, b. Armenia (1904–1948)
19 **The Betrothal,** 1947
Oil on canvas
128.9 x 101.6 cm (50¾ x 40 in)
1980.12.45 [color section]

Graves, Morris (b. 1910)
20 **Daisies in a Footed Vase,** 1949–1950
Gouache and pastel
35.2 x 31.6 cm (13⁷/₈ x 12⁷/₁₆ in)
1980.12.34

Graves, Morris (b. 1910)
21 **Time of Change**
Silkscreen
60.9 x 76.0 cm (24 x 29¹⁵/₁₆ in)
1980.13.49

Greene, George (b. 1908)
22 **Blue Horizon II,** 1973
Plexi-glass construction
H. 26.0, W. 24.7, D. 4.5 cm
(10¼ x 9¾ x 1¾ in)
1980.13.25

17

94

RD57 18

Grillo, John (b. 1917)
23 **Abstraction,** 1960
Tempera
72.0 x 57.0 cm (28⁵⁄₁₆ x 22½ in)
1980.13.76

Grillo, John (b. 1917)
24 **Untitled**
Oil on canvas
71.6 x 22.7 cm (28³⁄₁₆ x 8¹⁵⁄₁₆ in)
1980.13.26

Grillo, John (b. 1917)
25 **Untitled**
Oil on canvas
152.4 x 215.7 cm (60 x 85½ in)
1980.13.77

Hale, Robert B. (b. 1901)
26a recto: **Man of War,** 1959
26b verso: **This Life of Frolic,** 1959
Ink
73.4 x 58.0 cm (28⅞ x 22¹³⁄₁₆ in)
1980.13.50a, b

Kahn, Wolf (b. 1927)
27 **Girl with Anemones,** 1957
Pastel
56.0 x 38.0 cm (19¹⁵⁄₁₆ x 15 in)
1980.12.29

de Kooning, Willem, b. Holland
(b. 1904)
28 **Untitled, No. 2,** ca. 1957–65
Oil, paper towels and cigarette butt on
newspaper mounted on board
68.3 x 51.0 cm (27¼ x 20⅝ in)
1980.12.30 [color section]

de Kooning, Willem, b. Holland
(b. 1904)
29 **Untitled XIII,** 1975
Oil on canvas
220.5 x 195.5 cm (87¼ x 77 in)
1980.12.7 [color section]

23

26

97

Leslie, Alfred (b. 1927)
30 **Abstract Collage**
Oil on paper
16.3 x 14.0 cm (6⅜ x 5½ in)
1980.13.41

Marca-Relli, Conrad (b. 1913)
31 **Mother and Child,** 1955
Sepia ink on canvas
30.0 x 26.4 cm (11¹³⁄₁₆ x 10⅜ in)
1980.13.53

Marca-Relli, Conrad (b. 1913)
32 **The Upheaval,** 1956
Oil on canvas
178.0 x 210.0 cm (69⅞ x 82½ in)
1980.13.66

Marca-Relli, Conrad (b. 1913)
33 **No. 7**
Collage, oil on canvas
86.3 x 104.1 cm (34 x 41 in)
1980.13.71

Mitchell, Joan (b. 1926)
34 **Lac Achigon,** 1973
Oil on canvas
240.7 x 180.0 cm (94¾ x 70⅞ in)
1980.12.70

Mueller, Jan (1922–1958)
35 **Untitled**
Oil on canvas
21.0 x 23.2 cm (8¼ x 9⅛ in)
1980.13.31

Mueller, Jan (1922–1958)
36 **Untitled**
recto: Oil on paper, mounted on board
verso: Oil on board
25.0 x 17.4 cm (9⅞ x 6⅞ in)
1980.13.28a,b

30

Mueller, Jan (1922–1958)
37 **Untitled**
Oil on canvas
20.0 x 20.0 cm (7⅞ x 7⅞ in)
1980.13.29

Mueller, Jan (1922–1958)
38 **Untitled**
Oil on canvas
30.8 x 23.5 cm (12⅛ x 9¼ in)
1980.13.30

Platt, Charles Adams (1861–1933)
39 **Honfleur,** 1887
Etching
26.0 x 35.0 cm (10¼ x 13¹³⁄₁₆ in)
1980.13.72

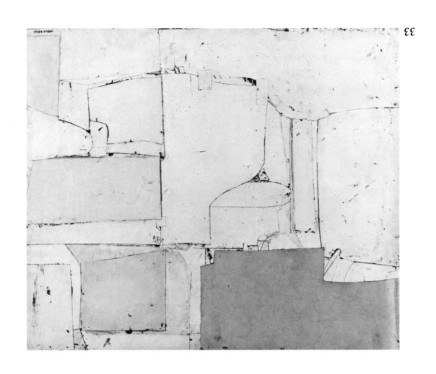

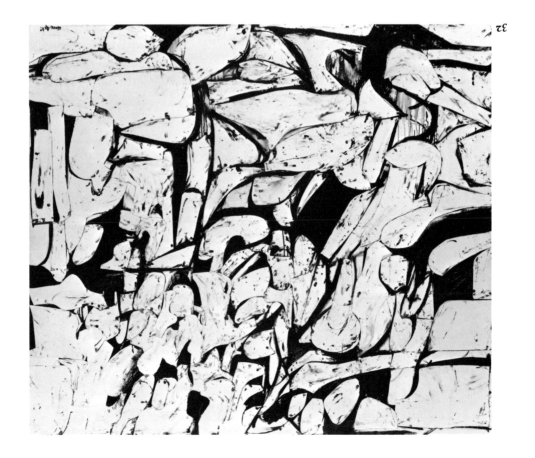

34

36

37

42

43

46

Pollock, Jackson (1912–1956)
40 **No. 4**, 1949
Oil, enamel and aluminum paint with
pebbles on cut canvas on composition
board
90.5 x 87.3 cm (35⅝ x 34⅜ in)
1980.12.6 [color section]

Pollock, Jackson (1912–1956)
41 **Number 14: Gray,** 1948
Enamel on gesso on wove paper
57.8 x 78.8 cm (22¾ x 31 in)
1980.13.74 [color section]

Reinhardt, Ad (1913–1967)
42 **No. 7,** 1949
Gouache
56.9 x 78.2 cm (22⅜ x 30⅝ in)
1980.12.49

Rothko, Mark, b. Russia (1903–1970)
43 **Orange,** 1957
Mixed media on canvas
174.0 x 158.0 cm (67⅛ x 62¼ in)
1980.12.50

Rothko, Mark, b. Russia (1903–1970)
44 **No. 3,** 1967
Mixed media on unprimed canvas
205.1 x 193.0 cm (81 x 75¹⁵⁄₁₆ in)
1980.12.23 [color section]

Rothko, Mark, b. Russia (1903–1970)
45 **Untitled,** 1954
Mixed media on unprimed canvas
235.5 x 142.7 cm (93 x 56³⁄₁₆ in)
1980.12.24 [color section]

Ryan, Anne (1889–1954)
46 **No. 97 (?),** ca. 1950
Paper and fabric collage
28.0 x 21.5 cm (11 x 8½ in)
1980.13.20

Sander, Ludwig (b. 1906)
47 **Colder,** 1968
Lithograph
42.6 x 40.0 cm (16¾ x 15¾ in)
1980.13.73

Steinberg, Saul (b. 1914)
48 **Hanging on T.V. Aerial,** 1951
Pen and ink with crayon
36.8 x 29.1 cm (14½ x 11⁷⁄₁₆ in)
1980.12.51

Steinberg, Saul (b. 1914)
49 **Bathtub,** 1950
Pen and ink with gouache
28.8 x 37.0 cm (11⅜ x 14⅝ in)
1980.12.52

48

52

EUROPEAN ART

Bonnard, Pierre
French, 1867–1947
50 **Interior at Le Cannet,** 1938
(retouched 1943)
Oil on canvas
126.4 x 125.1 cm (49¾ x 49¼ in)
1980.12.19 [color section]

Bonnard, Pierre
French, 1867–1947
51 **Interior with Table and Sideboard,**
ca. 1942–44
Gouache and black chalk on paper
43.5 x 47.5 cm (17⅛ x 18¾ in)
1980.12.20 [color section]

Bonnard, Pierre
French, 1867–1947
52 **Pine Tree,** ca. 1930
Oil on canvas
46.2 x 40.0 cm (18⅜ x 15¾ in)
1980.12.18

Brancusi, Constantin
French, b. Rumania, 1876–1957
53 **Mlle. Pogany II,** 1925
Polished bronze sculpture
H. 43.5 cm (17⅛ in)
1980.12.16 [color section]

Braque, Georges
French, 1882–1963
54 **Helios V,** 1948
Color lithograph
55.8 x 47.7 cm (21¹⁵⁄₁₆ x 18¾ in)
1980.13.44

Gris, Juan
Spanish, 1887–1927
55 **Still Life with Pipe,** 1917–18
Watercolor, gouache and pencil
on paper
29.2 x 23.3 cm (11½ x 9⅛ in)
1980.12.26 [color section]

Guys, Constantin
French, 1802–1892
56 **Horse-Drawn Carriages Riding
in a Park**
Ink and wash
27.0 x 39.0 cm (10⅝ x 15⅜ in)
1980.12.27

Klee, Paul
Swiss, 1879–1940
57 **Joyful Mountain Landscape,** 1929
Oil on board
43.9 x 63.1 cm (17⁵⁄₁₆ x 24⅞ in)
190.12.22 [color section]

Knoop, Guitou
French, b. Russia 1909
58 **Untitled,** 1965
Bronze
14.9 x 7.5 x 6.6 cm (5⅞ x 3 x 2⅝ in)
1980.13.51

Launois, Jean
French, 1898–1942
59 **Reclining Nude**
Watercolor and graphite
24.0 x 32.0 cm (9⅜ x 12⅝ in)
1980.13.52

LeParc, Julio
French, b. Argentina 1928
60 **Continual Light-Forms in Contortion,**
ca. 1966–71
Steel and light construction
82.0 x 50.3 x 25.2 cm
(32¼ x 19¾ x 10 in)
1980.13.54

Matisse, Henri
French, 1869–1954
61 **Nude in Rocking Chair,** 1914
Transfer lithograph
50.3 x 32.9 cm (19¹³⁄₁₆ x 12¹⁵⁄₁₆ in)
1980.12.32

Matisse, Henri
French, 1869–1954
62 **Standing Female Nude,** 1914
Transfer lithograph
50.3 x 32.9 cm (19¹³⁄₁₆ x 12¹⁵⁄₁₆ in)
1980.12.31

Moore, Henry
English, b. 1898
63 **Sketches for Sculpture,** 1944
Pencil, pen and ink and wash
22.4 x 17.0 cm (8⅞ x 6¾ in)
1980.12.9a & b

Ozenfant, Amédée
French, 1886–1966
64 **Kneeling Bathers,** 1930
Relief drawing with clay and oil
on canvas
44.0 x 52.8 cm (17⅜ x 20⅞ in)
1980.13.75

Pascin, Jules
French, 1885–1930
65 **Paris-Juno-Minerva-Venus**
Pen and ink, watercolor on canvas
on cardboard
33.0 x 49.7 cm (13 x 19⁹⁄₁₆ in)
1980.12.25

Picasso, Pablo
Spanish, 1881–1973
66 **Boy on Horseback,** ca. 1905
Black chalk over pencil
23.7 x 16.0 cm (9⁵⁄₁₆ x 6¼ in)
1980.12.28 [color section]

Picasso, Pablo
Spanish, 1881–1973
67 **Sea Shells on a Piano,** 1912
Oil on canvas (oval)
24.1 x 41.0 cm (9½ x 16⅛ in)
1980.12.8 [color section]

Picasso, Pablo
Spanish, 1881–1973
68 **Seated Woman,** 1947
Oil on canvas
99.9 x 80.7 cm (39⁵⁄₁₆ x 31¾ in)
1980.12.21 [color section]

Picasso, Pablo
Spanish, 1881–1973
69 **Ceramic Plate** with goat's head
facing right
Glazed egg shell ceramic
Diameter ca. 26.5 cm (10½ in)
1980.13.57

Picasso, Pablo
Spanish, 1881–1973
70 **Ceramic Plate** with male figure
playing flute at left and dancing female
figure at right
Unglazed egg shell ceramic
Diameter ca. 31.5 cm (12½ in)
1980.12.48

Picasso, Pablo
Spanish, 1881–1973
71 **Ceramic Plate** with three horsemen
and figure playing the flute
Unglazed egg shell ceramic
Diameter ca. 36.5 cm (14½ in)
1980.12.47

Moore 44

78

79

Picasso, Pablo
Spanish, 1881–1973
72 **Ceramic Plate** with picador at left
and toreador and bull at right
Glazed egg shell color ceramic
Diameter 43.5 cm (17⅛ in)
1980.13.55

Picasso, Pablo
Spanish, 1881–1973
73 **Plate** with head facing left
Glazed terra cotta with design in grey
Diameter 36.5 cm (14⅜ in)
1980.13.56

Picasso, Pablo
Spanish, 1881–1973
74 **Jar**
Gray, orange and egg shell fired pottery
54.5 x 43.0 cm (21½ x 17 in)
1980.12.46

Renoir, Pierre-Auguste
French, 1841–1919
75 **Mont Sainte-Victoire,** 1889
Oil on canvas
53.0 x 64.0 cm (20⅞ x 25¼ in)
1980.12.14 [color section]

Rouault, Georges
French, 1871–1958
76 **Crucifixion,** ca. 1930–39
Oil on board
40.3 x 30.2 cm (15⅞ x 11⅞ in)
1980.12.11 [color section]

Rouault, Georges
French, 1871–1958
77 **Nude Torso from the Back,** ca. 1906
Oil on paper adhered to canvas
72.4 x 57.8 cm (28½ x 22¾ in)
1980.12.10 [color section]

Rouault, Georges
French, 1871–1958
78 **Three Figures in a Moonlit Landscape,**
1914
Black chalk, ink, and gouache
19.0 x 29.5 cm (7½ x 11⅝ in)
1980.12.13

Rousseau, Henri
French, 1844–1910
79 **The Canal,** ca. 1905
Oil on canvas
30.8 x 40.0 cm (12⅛ x 15¾ in)
1980.12.12

van Ruysdael, Salomon
Dutch, ca. 1602–1670
80 **View of Alkmaar,** ca. 1650
Oil on panel
36.0 x 52.0 cm (14½ x 20½ in)
1980.12.33

Vuillard, Edouard
French, 1868–1940
81 **The Luncheon,** ca. 1895–97
Oil on cardboard
40.0 x 35.1 cm (15¾ x 13¹³⁄₁₆ in)
1980.12.17 [color section]

Anonymous
French, 19th century
82 **Madonna and Child**
Wood
36.0 x 12.0 x 6.5 cm (14⅛ x 4⅞ x 2⁹⁄₁₆ in)
1980.13.11

85

87

MEXICAN ART

Tamayo, Rufino (b. 1899)
83 **Dancers**
Lithograph
56.9 x 46.9 cm (22⅜ x 18⁷⁄₁₆ in)
1980.13.59

Tamayo, Rufino (b. 1899)
84 **Figure**
Lithograph
56.8 x 46.8 cm (22⅜ x 18⁷⁄₁₆ in)
1980.13.58

Tamayo, Rufino (b. 1899)
85 **Street Scene with Two Women
and a Dog**, 1944
Oil on canvas
106.7 x 86.5 cm (41¹⁵⁄₁₆ x 34¹⁄₁₆ in)
1980.13.32

Tamayo, Rufino (b. 1899)
86 **Watermelons**
Lithograph
46.8 x 57.0 cm (18⁷⁄₁₆ x 22⅜ in)
1980.13.60

Tamayo, Rufino (b. 1899)
87 **Woman at Crossroads**, 1938
Watercolor
27.5 x 21.0 cm (10⅞ x 8¼ in)
1980.13.2

Tamayo, Rufino (b. 1899)
88 **Woman Washing Her Hair**, 1938
Watercolor
27.5 x 21.0 cm (10⅞ x 8¼ in)
1980.13.1

ORIENTAL ART

Cambodian (Khmer, late 12th–early
13th century)
89 **Head of Deity**
Grey stone
32.0 x 18.5 x 15.0 cm
(12⅝ x 7¼ x 5⅞ in)
1980.12.15

Chinese (Ching dynasty, 19th century)
90 **Ancestor Portrait**
Ink and color on silk (hanging scroll)
142.2 x 95.2 cm (56 x 37½ in)
1980.13.39

Chinese (18th century)
91 **Two Boys Playing in a Garden
with Sheep**
Tempera on silk (hanging scroll)
100.5 x 51.5 cm (39½ x 20¼ in)
1980.13.64

Chinese (17th–18th century)
92 **Geese at Waterside**
Ink and color on paper (hanging scroll)
133.0 x 49.5 cm (44½ x 19½ in)
1980.13.42

Chinese (Ming dynasty, 19th century)
93 **Reading a Text on the Back of a Buffalo**, ca. 1861
Ink and color on silk (hanging scroll)
131.5 x 65.4 cm (51¾ x 25¾ in)
1980.13.36

Chinese (Ming dynasty)
94 **Egret at a Waterside**
Painting on silk
29.5 x 18.75 cm (11⅝ x 7⅜ in)
1980.13.27

Attributed to Chang ching-nan (or Chang chin), Chinese (1691–1745)
95 **Eagle on Rock**
Ink on paper (hanging scroll)
123.0 x 66.5 cm (48½ x 26¼ in)
1980.13.37

Chinese, in the style of Ch'iu Ying (Ching dynasty, 18th century)
96 **Presentation of Gifts in a Garden**
Tempera on silk
28.5 x 113.0 cm (11½ x 44½ in)
1980.12.53

Chinese, after Ma Yuan (Ming dynasty)
97 **Man in Hut in Winter**
Album: ink and color on silk
26.5 x 30.5 cm (10½ x 12 in)
1980.12.36

Wu Huan, Chinese (active ca. 1770)
98 **Birds Among Bamboo and Peonies**
Ink and color on silk (hanging scroll)
127.0 x 61.0 cm (50 x 24 in)
1980.13.38

Indian (17th–18th century)
99 **15 miniatures**
Tempera on paper
Various sizes
1980.12.55-69

Japanese (18th–19th century)
100 **Peonies**
Tempera and gold leaf on paper, two-panel screen
166.5 x 87.5 cm (65½ x 34½ in)
1980.13.61

Japanese (Edo period)
101 **Peony with Blue Flowers**
Tempera and gold leaf on paper
47.0 x 62.0 cm (18½ x 24⅜ in)
1980.13.62

Japanese (19th century)
102 **Scene from the Tale of Genji**, ca. 1800
Ink, tempera and gold leaf on paper
22.0 x 16.3 cm (8⅝ x 6⅜ in)
1980.12.37A

89

Japanese (19th century)

103 **Scene from the Tale of Genji**, ca. 1800
Ink, tempera, and gold leaf on paper
22.0 x 16.3 cm (8⅝ x 6⅜ in)
1980.12.37B

Japanese (19th century)

104 **Scene from the Tale of Genji**, ca. 1800
Tempera and gold leaf on paper
22.0 x 16.3 cm (8⅝ x 6⅜ in)
1980.12.37C

Japanese (19th century)

105 **Scene from the Tale of Genji**, ca. 1800
Tempera and gold leaf on paper
22.0 x 16.3 cm (8⅝ x 6⅜ in)
1980.12.37D

Japanese (Edo period, 18th century)

106 **Scene from the Tale of Genji**
Tempera on paper, two-panel screen
72.5 x 83.0 cm (28½ x 32¾ in)
1980.13.21

Japanese (late 18th century)

107 **Scenes from the Tale of Genji**
Tempera and gold leaf on paper,
three-panel screen
118.7 x 172.0 cm (46¾ x 67¾ in)
1980.12.54

Japanese (18th century, Kanō school)

108 **Cherry Blossoms and Stream**
Tempera and gold leaf on paper,
six-panel screen
149.0 x 342.4 cm (58⅝ x 134¾ in)
1980.13.35

Japanese (18th century, Kanō school)

109 **Cranes and Birds in Landscape**
Tempera on paper, six-panel screen
150.0 x 352.0 cm (59 x 138½ in)
1980.12.35

Japanese (18th century, Kanō school)

110 **Landscape**
Ink and gold on paper, six-panel screen
161.5 x 356.9 cm (63⅝ x 140½ in)
1980.13.34

Japanese (late 18th–early 19th century,
Rimpa school)

111 **Basket of Flowers**
Ink and color on gold paper
21.0 x 18.3 cm (8¼ x 7³⁄₁₆ in)
1980.12.75

Japanese (late 18th–early 19th century,
Rimpa school)

112 **Peonies, Rock and Bamboo**
Ink and color on gold paper
21.6 x 19.7 cm (8½ x 7¾ in)
1980.12.74

Japanese (Edo period, Rimpa school)

113 **Peonies with Red, White, Blue
Flowers**
Gold leaf and tempera on paper
47.7 x 62.0 cm (18¾ x 24⅜ in)
1980.13.63

Japanese (late 18th–early 19th century,
Rimpa school)

114 **Taoist Immortal (?) Riding Tortoise
on Waves**
Ink and color on gold paper
22.0 x 16.5 cm (8⅝ x 6½ in)
1980.12.73

Kitagawa Utamaro, Japanese
(1754–1806)

115 **Night Pass in the Snow
(Yuki no Yomichi, ca. 1790–95)**
Color woodblock print
37.0 x 23.5 cm (14½ x 9⅜ in)
1980.12.38

125

136

139

MISCELLANEOUS

African (Bapende, late 19th–early
20th century)
116 **Dance Headdress (?)**
Wood
H. 30.5 cm (12 in)
1980.13.24

African (Fang, late 19th–early
20th century)
117 **Reliquary Head**
Wood
H. 39.3 cm (15½ in)
1980.13.23

African (Yoruba, 20th century)
118 **Female Figure,** after 1950
Wood (iroko?)
H. 30.5 cm (12 in)
1980.13.40

Australian (19th–20th century)
119 **Bark Painting, Landscape
with Birds and Pond**
White, yellow and red pigments on a
black ground
32.0 x 47.5 cm (12⅝ x 18¾ in)
1980.13.3

Byzantine (late 16th century or later)
120 **Synod of Bishops**
Tempera on wood
16.4 x 19.7 cm (6½ x 7¹³⁄₁₆ in)
1980.13.4

Juanita Pino
(native American, 20th century)
121 **Ceramic pot**
H. 16.6 cm (6½ in)
1980.13.18

North American, possibly Alaskan
(early 19th century)
122 **Scrimshaw**
Ivory and ink
3.0 x 10.2 x 0.8 cm (1⅛ x 4 x ¼ in)
1980.13.9

North American, possibly Alaskan
(early 19th century)
123 **Scrimshaw**
Ivory and ink
2.0 x 43.5 x 0.9 cm (⅝ x 17 x ⅜ in)
1980.13.8

North American, possibly Alaskan
(early 19th century)
124 **Scrimshaw**
Ivory and ink
1.8 x 46.1 x 0.4 cm (¾ x 18⅛ x ³⁄₁₆ in)
1980.13.7

Peruvian, Paracas (7th–3rd century B.C.)
125 **Textile fragment**
Cotton and llama (or alpaca) wool
24.0 x 14.5 cm (9½ x 5¾ in)
1980.12.5

Peruvian, Paracas (7th–3rd century B.C.)
126 **Textile fragment**
Cotton and llama (or alpaca) wool
9.5 x 12.5 cm (3¾ x 4⅞ in)
1980.12.72

Peruvian (pre-Columbian,
Nazca Valley, Coastal Wari style,
2nd–9th century)
127 **Pitcher**
Burnished redware
19.0 x 14.2 x 8.0 cm (7¾ x 5⅝ x 3¼ in)
1980.13.16

Peruvian (5th century)
128 **Bowl**
Painted ceramic
7.7 x 13.3 cm (3 x 5¼ in)
1980.13.5

Peruvian, Chancay (12th–15th century)
129 **Textile fragment**
Cotton and llama (or alpaca) wool
68.5 x 59.5 cm (27 x 23½ in)
1980.12.71

Peruvian, Chancay (12th–15th century)
130 **Textile fragment**
Cotton and llama (or alpaca) wool
31.0 x 37.0 cm (12 x 14½ in)
1980.12.4

Peruvian, Inca (15th–16th century)
131 **Textile fragment**
Cotton and llama (or alpaca) wool
15.0 x 37.0 cm (5⅞ x 14½ in)
1980.12.2

Peruvian, Chancay (12th–15th century)
132 **Textile fragment**
Cotton and llama (or alpaca) wool
43.0 x 34.5 cm (17 x 13½ in)
1980.12.3

Peruvian, Chimu (?)
(12th–15th century)
133 **Textile fragment**
Cotton
18.0 x 30.5 cm (7 x 12 in)
1980.12.1

Peruvian (20th century)
134 **Chimu Stirrup Spout
Blackware Vessel**
Probably 20th-century imitation of
14th-century vessel
Blackware
20.5 x 16.5 x 10.6 cm (8 x 6⅝ x 4⅛ in)
1980.13.19

Mexican, Teotihuacan
(3rd–6th century)
135 **Face Panel**
Calcite (cave onyx)
17.5 x 16.4 x 6.8 cm (7 x 6½ x 2½ in)
1980.13.12

Mexican, Aztec (15th century)
136 **Kneeling Female Figure**
Light brown lava
34.0 x 19.0 x 14.3 cm
(13¾ x 7½ x 5⅝ in)
1980.13.22

Mexican, Mezcala (20th century)
137 **Olmec-style Human Figure**
Probably 20th-century imitation of
classic era (?)
Greenstone
22.5 x 12.0 x 8.5 cm (8⅞ x 4¾ x 3¼ in)
1980.13.34

Mexican (20th century)
138 **Headdress Ornament**
Probably 20th-century imitation of
pre-classic era
Greenstone
8.5 x 4.2 x 3.0 cm (3⅜ x 1⅝ x 1¼ in)
1980.13.6

Mexican, Mezcala (date unknown)
139 **Stone Knife in Human Shape**
Greenstone
24.0 x 6.2 x 4.2 cm (9½ x 2½ x 1¾ in)
1980.13.13

Spanish American (15th–16th century)
140 **Crucifixion Among the Three Marys**
Wood relief
17.5 x 17.8 x 6.0 cm (6⅞ x 7 x 2⅜ in)
1980.13.10

Design & Typography by Howard I. Gralla

Composition in the Dante and Perpetua types by Michael & Winifred Bixler

Photographs by Joseph Szaszfai and Geraldine T. Mancini

Printed by The Meriden Gravure Company · Bound by Mueller Trade Bindery

Production Supervision by Yale University Printing Service